HANS-CHRISTIAN DANY
VALÉRIE KNOLL

No Dandy, No Fun
Looking Good as Things Fall Apart

The book is published as a sequel to the exhibition "No Dandy, No Fun" (curated by Hans-Christian Dany and Valérie Knoll), which was shown at the Kunsthalle Bern from October 17, 2020 to February 14, 2021.

By the time the bottle uncorked itself, it had already been following me around for some time. On its surface, bubbles effervesced. Then, as I watched them pop, it got into my head. It went from being stern-faced to lapsing into childish silliness. One moment it would touch lightly on the surfaces of things; the next it would gaze into their depths. Every time I tried to fix my gaze on it, it would bewilder me with its sudden movements. It moved from left to right, crosswise and backwards. One moment it was lurching about, the next it was walking calmly in a straight line. It behaved like someone who'd been born with a silver spoon in their mouth. Then it dreamt up parents it had never had, to complement this fictional life. Though it may have had only limited choices in determining its course of life, it spurned the future that had been set out for it. It swept under the carpet everything it had been handed at birth—the playbook of its life, the guilt and debts it had been left with, its culture, class, gender, and ancestry. Instead of accepting its allotted role, it invented who it might be. But while its body donned new disguises, vestiges of what it had cast off still clung to it. To escape who it was, it had to struggle both with what it did not choose to become and with what it could not be. Its transformations followed uneven paths and attempted to span unbridgeable chasms. Contradiction was its middle name.

To many people, it seemed like a will-o'-the-wisp from another time, an outmoded cliché strolling through the arcades of Paris with a turtle on a leash. I didn't care what they thought. God knows where this current fixation on our own time will lead. I watched it, fascinated, almost a little in love. The sight of this contemporary anachronism moved me. I could barely sit still, spent the whole time walking up and down until suddenly I stood in front of the window. In the street below, teenagers slouched past, their shoulders stooped. They looked as if they had only one thing to say to the world: go fuck yourself. It was at this moment that I started calling the ghost a dandy. But what was a dandy?

We often speak about dandies the way we speak about art. Half-sentences slink around something that cannot be defined more precisely. Even to begin to understand it, we would need a language of blank spaces and lacunae. But the fact that it cannot be expressed does not mean that the dandy is a matter of personal opinions, any more than art is simply a matter of taste. Although the meaning of the term "dandy" can be precisely formulated, I hesitate to say whether it is one thing or another. It is not just that I have qualms about defining it from the outside; it is also that hardly anyone says of themselves: I am a dandy. That's for others to do. The external definition refers to an idealized character from the realm of literature. Which is why the dandy can walk through library walls, but his flesh-and-blood version has greater difficulties hanging out in bars. These days almost no one seeks to emulate his stance. The ghost has been out of the picture for quite some time. By the 2000s, Karl Lagerfeld was already remarking that "the term 'dandy' is alien to me as far as my personality is concerned. That poor word, that poor man—they've had to answer for everything." Karl

knew what he was talking about. It was all over for the dandy. Although it wasn't the first time he'd died. Ever since he'd come into the world two hundred years earlier, his corpse had been repeatedly buried. The zombie generally returned when the gap between the old and the new opened up with no picture of the future in sight. As Baudelaire put it, "dandyism appears especially in periods of transition." And we are living through a time in which the old world is collapsing. At this point I heard a voice. It said: you're looking for him now. I rarely hear voices, so I followed this one. To go looking for the dandy felt both perverse and right. The notes I've taken during the search make no claim to offer the whole picture. How could they? As Paul Valéry put it, "Even the most comprehensive story provides only 0.00001% of observed reality—and to do so relies on the crudest of opinions—the rest is left obscure." What emerged is a portrait full of gaps and discontinuities. Sometimes it felt as if I was writing a love letter, at other times as if I was writing the voiceover to a film whose footage had been lost. Many might think that my sympathies are so torn that I let the dandy off lightly. But doesn't passion raise your expectations?

While I circled round the relic making notes, I looked for an image of the future. The term "to imagine" is related to remembrance, and dates back to the Roman custom of bearing through the town the *imagines*, the death masks of ancestors, as a way of transporting their spiritual heritage into the future. Heritage can mean the claim that the dead place upon the living to put their legacy in order. My attempt to bring order to this personality composed of many individuals owes less to the lost honor of our ancestors than it does to the kindness of an elective family. It links together a stance that has been handed down from generation to generation. Though it is

3

worn and has passed through many hands, this inheritance tells the story of the search for an autonomous life.

Those expecting anecdotes from the lives of privileged and well-dressed men are likely to be disappointed. While they do feature, I am more interested in the dandy as a destabilizing entity, who is not above playing with a deck of marked cards. A character who wants to be neither good nor a victim, which frees him from the burden of gazing down upon others from some Olympian moral heights.

The First of His Kind

London, June 7, 1778. A chubby little boy first sees the light of day. Everyone said he was sweet, although in truth the baby was not beautiful. George Bryan Brummell had first to make something of himself. The son of a sheriff who had become private secretary to the prime minister, he had an unremarkable childhood. But after reaching puberty he became a style icon of the English aristocracy. Brummell, a precursor of Bryan Ferry, remains to this day a model with which every iteration of dandyism has been compared. It was a modest standard, given that he said of himself that his only talent lay in wearing clothes.

Brummell's father had used his contacts to help him get into the most exclusive regiment of the British army. Surrounded by the sons of aristocratic families, Brummell avoided looking stupid by adopting the attitudes of the upper classes. He fitted in by looking down on the middle classes and treating the lackies like dirt. Soon he found his imitation somewhat tedious. Why play the part of a conmen impersonating the customs of the ruling class, when the downfall of that class is so obviously in sight?

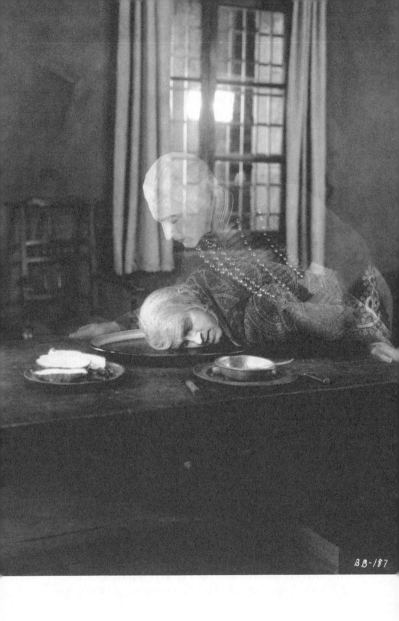

Brummell now began to exaggerate, inventing his own rules and adopting manners of behavior so unsettling that they occasionally won him a slap in the face. By staging his own dramatic entrances, he stole from the aristocrat the privilege of seeing his own personality as something malleable. In the course of these performances he quickly discovered how much the privileged liked being insulted by him. This was something new to them, and in their ennui they sensed that Brummell's humiliations were aimed at making the imminent collapse of their class more bearable.

By relieving his milieu's anxieties about the future, Brummell began a rapid rise in the court of the Prince of Wales. His ascent was aided by the fact that the future King George IV was in love with him. But ascribing this outsider's rise to stardom in aristocratic society to this affair alone would be an oversimplification. It merely provided Brummell's entry onto the stage where he could develop his magic. The seducer was now on everyone's guest list. His presence at an occasion was soon essential to guarantee its success. His absence ensured that it came to nothing. The blue bloods were prostrate before him, as if he'd set the moon in the sky. Brummell found he needed to do no more than dispense carefully calculated cruelties. He simply looked good and a lot better than his audience, despite not being, as they say, naturally good looking. His fame grew and proliferated in innumerable rumors. Everyone was talking about him, first in London and then across the whole of England. In 1815, after an alliance led by the English general Wellington had delivered a crushing defeat to the French at Waterloo, he launched himself upon the European continent. With the fall of Napoleon Bonaparte and the French Empire, an attitude that had originated in England also conquered Paris. The

jeunesse dorée of the defeated nation now strolled up and down the Champs-Élysées dressed for a duck-shooting party on an English lake.

Inventing a Character

It took a while before a mania for British chic turned the dandy into an iconic figure of French literature. The opening salvo was fired by Jules Barbey d'Aurevilly, a monarchist who resented the republican age in which he lived. His treatise *On Dandyism* (*Du Dandysme et de G. Brummel*, 1845) was not the first book on the subject; the dandy had already provided the model for two novels. However, Barbey developed the idea that Brummell and his way of life represented a new philosophical figure, one that did not see his identity as given, but rather as something he could shape. Although Barbey would describe with amusement the pains Brummell took in knotting his neckcloth, he remained uncertain whether the dandy was an entertaining alternative to the bourgeois way of life or simply a symptom of decadence. Folding little pieces of silk seemed somewhat ridiculous. Soon enough, though, everyone was imitating him, and the cravat became an essential article of clothing. For his next ruse, Brummell combined an aristocrat's tailcoat with long, straight-cut trousers, the *pantalons* of the French workman. These two pieces of clothing, which straddled the class divide, constituted an undreamt-of combination which would become the uniform of the modern man.

Brummell considered his public appearances to be successful only when he did not stand out too much. If he drew stares, it meant he had got something wrong. He did not want to come across as eccentric. What he did func-

tioned within the existing order according to a different register, but did not seek to forsake it. His aim was to distinguish himself from those who simply wanted to conform and who therefore had no inhibitions about being boring. But he did not want to be an isolated bird of paradise either; instead, he subtly poached ideas wherever he could find them. By the process of shifting what had previously been considered the norm, Brummell developed a heightened awareness of casual and fleeting changes. Things he'd previously strictly insisted upon he now deliberately neglected. Suddenly a dirty collar peeked out from beneath his resplendent jacket. Gradually he accumulated these deliberate errors to create a serene disorder, to the point where it seemed as if he had happened to throw on a random assemblage of rags.

This laissez-faire attitude went beyond the relaxed manner of those who had inherited their social position by birth. Then as now, being rich or noble meant having the freedom to dress appallingly badly. Since you already were someone, why bother to make something of yourself? Brummell gave this tired sense of taste a cool twist. Apart from his casual style, it was the ability to do more with less that would turn Brummell into a precursor of modern elegance. There were also mundane reasons behind his simple black suit. Brummell's minimalism hid the fact that he had fewer means with which to look good. To hide his impecuniousness, he would wrap it in anecdotes, like the one that he used champagne to polish his boots. Unlike the snobs—the *s(ine) nob(ilitate),* those without noble titles—who tried to compensate for their non-aristocratic origins by acquiring lavish status symbols, Brummell's flirtation with luxury items had a wholly different character. While the snobs professed an enormous respect for the upper classes, the dandy held

their adopted symbols in contempt and cultivated instead a ruin chic, typified by his suit, which he would rub with glass shards to give it a shiny and delicate texture. At every level, he challenged the values of the established order to a duel, rejecting any compromise and demanding satisfaction. His belligerent charm included a refinement of the arts of insult and gossip, which pushed the possibilities of language to its limits. This gained him respect. His verbal barbs and reputation as a dangerous opponent meant he could take almost any liberty. Many admired his audacious verbal repartee, and not a few envied him, arguably the highest form of flattery. They would obsequiously compliment his elegant shoes, then attack him behind his back at the first opportunity. He kept his distance simply to avoid gossip and, by affecting a languid detachment, let the attacks and the meddling roll off his back. But behind the mask of bored lethargy he needed to do something to avoid exposure. Despite this, he undertook nothing that could be called work; instead he killed time and played dice as if he could make his own luck without lifting a finger. Only when he felt particularly bored would he scribble a poem on a piece of paper or sketch a willow with its hanging branches. When a pimple prevented him from going out for a week, he wrote a book on fashion in antiquity. These fits of mood enabled him to avoid showing any visible ambition. In hindsight one might have thought he needed to do so. It was also said that he was rich. Brummell had long ago run through his modest inheritance. No one knew where the money to maintain his extravagant way of life came from, until the day when he was no longer able to hold at bay his long line of creditors. Brummell had already been bankrupt for some time. But why declare his insolvency? Explanations were a bore. That

very evening, he got into a coach after the opera and, instead of asking the coachman to take him home, ordered him to drive him to Dover, where he boarded a ship for France the same night. Several contemporaries compared his escape in 1816 to Napoleon's passage into exile on Elba. The hyperbole is revealing, and an indication of how effective Brummell was at getting people to believe his own fabrications.

My fingers jumped from the keyboard as something loud exploded outside. When I went to the window and looked down at the street, I saw a folk group from the Swiss Alps laughing as they gathered up bank notes. The cash machine looked like a burst can of Cola Zero.

Fame of a Failure

On Wednesday, November 20, 1929 Virginia Woolf gave
a radio broadcast on the BBC. It was five weeks after the
New York stock exchange had crashed, ushering in the be-
ginning of the end of the modern era. As the world plunged
into an abyss whose depths no one at this point could
guess, Woolf posed the question of why this man, whose
legacy amounted to nothing more than debts and rumors,
had left behind such a lasting impression. She admired
the fact that Brummell was no sycophant or lickspittle.
She also recognized that his attitude to life involved tak-
ing for himself what was not meant for him. But then her
mini-biography turned to the second part of his life, the
years after he had fled London as a bankrupt. Woolf did
not gloss anything over. She described his deterioration
with a coolness bordering upon malice. Up until then, he
had stood for the promise of a better life, where people
no longer had to be born rich in order to enjoy the good
life. Then came the fall. His first port of call was Calais, a
common place of refuge for English bankrupts. Eventually
he washed up in Caen, a backwater not exactly known for
its elegance. By this point, everyone had had enough of
him. There were no longer any admirers to pay his restau-
rant bills. Polite society in the French provincial town
was not interested in the faded figure in his threadbare
clown suit who minced about its cobblestones on tiptoes.
To crown his miseries, the authorities had him locked up
in the debtor's prison. There, at least, he was liked by his
fellow inmates, and would preside over breakfast with all
the courtesy of an English lord. By lunchtime, however,
he was hunched over the bread soup, babbling about a
love affair with a long-dead countess. In the afternoon,
other ghosts came to visit, and by evening he was talking

pure nonsense. His mind gone, Brummell drew his last breath in a home for the destitute on March 30, 1840. Woolf's voice soberly informs us that he died, sordid and in rags, in the arms of two nuns, like a derelict who is forgotten even before their body is carted off. Brummell did not disappear from popular memory. He had too elegantly tweaked the noses of the powerful. Although his appearance had left a deep impression, he remained a ghost, and no one really knew who had been hidden behind his masks. Stories about the mysterious stranger continued to be told after his death. The image that emerged of him was not entirely complimentary. But it was precisely because of his ambiguity that he continued to be talked about. When Woolf pointed out that failure was the mark of the dandy, it did nothing to discourage dandyism. His dramatic fall merely embellished his stand against the injustice of a society founded upon noble birth. And her text underscores one other thing: here was someone who had lived but had only become an image through the gaze of others.

When the Body Matters

There is another, older, less well-known prototype of dandyism. He also emerged amid the gaze of others, but within far more deeply rooted power structures. In 1764, decades before the rise of Brummell, a ten-year-old boy was bundled on board a Royal Navy ship bound for London. Upon arrival, his abductors christened him Othello. There is no record of his original name; all we know is that he was born the son of a slave in St Kitts, Jamaica. The boy was sold to Catherine Douglas. The well-known eccentric, who bore the title the Duchess of

The D—of playing at FOILS with her favorite Lap Dog MUNGO after Expending near 10000 to make him a——

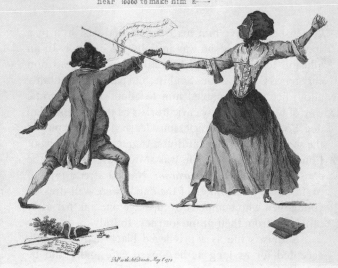

Queensberry, gave him his freedom and cast him in a spectacle of which she was initially the director. In an allusion to a noble French family name, she had him christened Othello Julius Soubise, and paid him a monthly allowance which enabled him to adopt an aristocratic way of life. Mocked by caricaturists as the duchess's lap dog, Soubise took acting lessons, learned to fence, played the violin and, in elegant dress, frequented the clubs of London's high society. He was so well dressed as to be considered one of the *macaroni*. Named after a type of pasta, these forerunners of the dandy were well-dressed young men who competed to upstage one another after returning from their grand journeys to Italy.

Soubise's life as a privileged black man was only accepted for as long as he looked cute and could be regarded as an object. Once he turned into a subject with its own will, the situation became tense. His special status came to a sudden end when he became suspected of having raped a servant girl. To avoid a trial which was unlikely to be fair, he fled to India. The real basis of the charges was never cleared up. In Calcutta he founded a fencing school that taught both men and women. But in India Soubise never found the social success that he had enjoyed at least for a while in London. Nevertheless, he ran up mountainous debts until he went bankrupt. Prison followed, together with an attempt on his life. His demise came at the age of forty-four, when he cracked his skull after falling from a horse.

EVERYBODY, Men, Women,
Children, Dogs, Cats and Other
Animals, Wild and Domestic,
Looked at Me—ALL the Time!
(Carter)

These are the words of Vincent O. Carter, describing how
the Bern of the 1950s gawped at him as if he were a visitor
from another planet. One day on the bus, an apparently
respectable old gentleman touched his hair, not stopping
even when his eyes went glassy and he started to shake
with emotion. His experiences as a regular at the Café
Rendez-vous near Bern's Monbijou Park—today the
Nelson pub—make clear that he could not be anyone else
even for a single day. Carter wrote a book about life un-
der this regime of constant staring, where he was contin-
ually being asked, why have you come here? *The Bern
Book* was published in English in 1973, but came out in
German (as *Meine weisse Stadt und ich*) only recently, as
part of the reaction to Black Lives Matter. Until then, no
one had been interested in it.

Although Julius Soubise is an archetype in the
mythology of black dandyism, it took a long time before
a comprehensive work was published on the subject.
Monica L. Miller's *Slaves to Fashion: Black Dandyism and
the Styling of Black Diasporic Identity* (2009) is a wide-
ranging portrayal of this history, which until that point
could only be pieced together through fragments and
remained completely ignored by the established dandy
narrative. While the white dandy was a textual figure
from the start, the image of black dandyism was preserved
only in oral history, and later in photographs or films.

In his book *Black Skin, White Masks* (*Peau noire,
masques blancs,* 1952), the doctor Frantz Fanon describes

how black dandyism offers a drastically limited range of disguises, whose opportunities are not available to all: "I arrive slowly in the world; sudden emergences are no longer my habit. I crawl along. The white gaze, the only valid one, is already dissecting me. I am *fixed*. Once their microtomes are sharpened, the Whites objectively cut sections of my reality. I have been betrayed. I sense, I see in this white gaze that it's the arrival not of a new man, but of a new type of man, a new species. A Negro, in fact!"

While it was possible for a white dandy to escape his legacy, whether that was the marks of his social background or, to a certain extent, his gender, the black dandy's means of escaping his external characteristics proved to be more limited. His body remained recognizable as that of a black man. Pretence seemed an almost impossible way of abandoning the color of his skin and escaping the fixed stare of the white gaze. Self-stagings of black dandyism often reacted to this impossibility by exaggerating their own distinguishing features and developing a heightened awareness of their own bodies. They distort what is visible, while also attempting strategies of invisibility.

But have I already written too much on what others could write much better? It would seem strange to me to tell the history of dandyism without at least hinting at its hidden aspects. However, black dandyism developed in a different cultural register, and in directions I would be cautious to describe, knowing little of its complex allusions and trajectory. I've already deleted most of what I've tried to write about it.

The Female Dandy

The dandy's rather grubby ethics were largely a masculine preserve, and in German the word itself has a masculine gender, *der Dandy*. This is a pity, since the feminine *die Dandy* sounds at least as good. The term's masculine gender also ignores the figure's feminine qualities. Until I realized how often dandies were men who wanted to be women, I tried to find female dandies under different names. First I came across *garçonne*, a term originating in the 1920s, who resembles the dandy in her rejection of the identity she has been assigned. The figure first appeared under the name of Monique Lerbier in Victor Margueritte's 1922 novel *La Garçonne*. But even at this point, the *garçonne* was turning into a fashion style for the working woman—Coco Chanel had already cut the trousers from Brummel's suit to fit the female body. As a result, the *garçonne's* supposed masculinity became, despite itself, a mere prototype of how capitalism appropriates currents of sexual liberation.

Among the other typologizations related to the dandy is the *femme fatale*, that sharply contoured, man-eating snake. This fantasy of the phallic woman soon proved to be both too simplistic and too exaggerated. Although the somewhat louche, sharply defined lady had an air of mystery, and although she expanded the then rather limited repertoire of female personae to include a cold, armor-clad and spiteful woman, at the end of the day she remained a two-dimensional image that served the male gaze. The same is true of the vamp, who emerged from the silent film *A Fool There Was* (1915). In it the main female protagonist is clearly identified as a species of vampire and ruins a kindly paterfamilias. The fact that the vamp's attention is

wholly focused upon the man indicates that we are dealing with just another male fantasy.

The diva seems to have more similarities with the dandy. She too is born with none of the privileges conferred by natural charisma, and must instead create them. She earns her audience in order eventually to turn her back on it. While she makes the best of what she has, dandies cultivate indolence, as if life were some childish distraction. Despite this, many dandies have admired divas and their aura of aloofness, recognizing them, for all their eccentricities, as kindred spirits. But what they have in common is that they like both being seen and hiding away. Brummell himself had sought the role of an object of aesthetic contemplation. In the early nineteenth century, the diva, a character closely associated with the development of the film industry, did not exist as a model of behavior for the dandy. Brummell's paradigm was the courtesan. The kept woman came from a humble background and rose to the upper echelons of society, where she spent much of her time waiting, an experience she used to refine her appearances in society. This high-class representative of the oldest profession cultivated an image of indolence, despite not having inherited the right to a life of leisure. Even before the appearance of the dandy, the courtesan pioneered experimental forms of dress, and placed herself at the cutting edge of fashion. At the same time, she elevated conversation to the art of rhetoric, presenting a figure of sophistication and urbanity. Many of them, such as Esther Pauline Blanche Lachmann, known as La Païva, or Marie Duplessis, better known as la Dame aux Camélias, won respect for the consummate mastery with which they constantly broke social conventions. Their stubborn self-confidence made them an object of literary fascination by (largely male) writers who felt

the constraints of bourgeois society too keenly. Balzac, Dumas, and Zola dedicated whole novels to the lives of courtesans, narrating their glittering successes and their abject humiliations. In the "misery and splendor" of these women's lives, these writers saw a promise of the debaucheries of which they dreamed. By borrowing from the courtesan, Brummell became a precursor of this literature.

Alongside fashion, social mobility, and an anarchic disposition, gossip was one of Brummell's principal concerns. Gossip offered an opportunity to appear as a well-informed, and therefore dangerous, person, who was capable of defending himself with his intimate knowledge of the world. The dandy used the appeal of rumor to build himself up as a countervailing force.

Today gossip almost always denotes scandal and malicious talk. But according to the philosopher Silvia Federici, until the late middle ages the term—a combination of the Old English word *god* (good) and the German word *sipp* (kin)—referred to a circle of female friends. It was in reaction to these social groups, which greatly strengthened the position of women by giving them opportunities to plot together, that the gossip's bridle was introduced in Scotland in the sixteenth century. Women who spoke for these groups were regarded as witches, and the gags were used to silence their dissenting truths and break up their communities. As a result, says Federici, the term gossip was transformed "from a word denoting friendship and affection into one that stood for slander and ridicule." When, at the beginning of the nineteenth century, dandies learned to gossip from watching the courtesans, it was considered by the men of the Enlightenment witchlike and underhand. Among enlightened, bourgeois men, women were held in quiet contempt, especially when they opened their mouths. By contrast, the

dandy—who had no desire to be a manly man—admired their notorious ability to use gossip as a means of defense.

The influence of the sexualized figure of the courtesan might seem surprising, given that dandies generally came across as asexual. After the excesses of his youth, Brummell himself behaved as if his own body were alien to him. Sex didn't interest him. Wasn't there something repulsive about senselessly sweating and grunting with someone in rhythmic movement? Like many homosexual dandies, Brummell could not of course acknowledge his desires. His affected indifference to carnality cannot be explained as a mere disguise. Dandies were often in love, and not necessarily with other men. Their reticence toward sex was part of their asceticism toward everything that appeared natural or all too human.

What He Wants Out of Her

Women, he thought, like it when they're being watched, and the mere thought that they might made him jealous. He wanted to be able to do whatever they could. Charles Baudelaire seemed to be utterly consumed by jealousy, and had no idea what to do about it other than to start a poisonous relationship with these threatening rivals. The writer went so far as to imagine that they were not dissimilar to animals: "a woman is hungry, and she wants to eat; thirsty, and she wants to drink. She is in heat and she wants to be served." Faced with feelings of inferiority, he sought to gain the upper hand by crudely denigrating his opponent to conceal his own weaknesses. Things were further complicated when Baudelaire did what a dandy should never do: he fell in love with the dancer and actress Jeanne Duval, with whom he had a decades-long relationship. From the dandy point of view, anyone who dedicated themselves to love was no longer in control of their life. We do not know how Jeanne Duval's life ended. All we know of her is that she was a formidable character, whom many found intimidating, and who set little store by social conventions and idle talk. While Baudelaire often denied this great love of his life, he raved about a woman he could never love: her boundless proclivity to seduce, her use of clothes to deceive, her profligacy, her need to celebrate life, and her eventual suicide by poisoning; to him, all this marked out Madame Bovary as a dandy. The main protagonist of Gustave Flaubert's eponymous novel was a body made of words, written by a man. Flaubert, who is reported to have said, *"Madame Bovary—c'est moi,"* had written himself into its heroine, and Baudelaire's admiration for this literary act of transvestism hid something more than a simple fear of the fe-

male body. The story had begun with an idea that contravened every literary convention of its day: all its power was to be derived from language, rather than from the content of its narrative. Baudelaire admired Flaubert's dedication to the composition of letters. By developing its powers of description, the novel succeeded in turning a deliberately shallow subject matter into a work without parallel. It also caused a scandal, which Flaubert survived by arguing at his trial: I have only ever quoted from reality; I am not personally advocating adultery.

Madame Bovary was an expression of Flaubert's love for the literary body, and Baudelaire recognized in it a form of writing where language could become a mirror. Baudelaire's call for self-examination has often been misunderstood: his idea that dandies should live and sleep in front of a mirror, which prefigured the self-referentiality of contemporary art, has given rise to the preconception that they are no more than self-regarding narcissists. But when he spoke about sleeping in front of the mirror, Baudelaire did not mean the narcissistic shock of meeting one's own gaze. Most dandies did not like what they saw in the mirror. They did not seek approval for the roles they assumed, neither their own nor those of others. On the contrary, they alienated both others and themselves. This partly explains why it is easier for men to assume the role of a dandy. It's not unusual for women not to care whether they are liked, but to deliberately make oneself dislikable and still be socially accepted has long been a privilege reserved for men. In the nineteenth century, few women could afford to deliberately risk their social position. And it would be highly disingenuous to ignore that, even to this day, most women are brought up to please others. Too often this social conditioning, which is deeply stamped on their subconscious, is dismissed as an obso-

lete prejudice, making the actual reality all the more painful. Women's upbringing systematically discourages them from disappointing expectations that are placed upon them. The dandy does not care what others think of him; for women to make this stance their own, they must reject an upbringing that has taught them to be obliging to others. For this reason alone, the story of the female dandy is not yet over.

The Horror of One's Own True Feelings

Baudelaire rejected the sentimental sincerity of late Romanticism. His praise of cold self-reflection stood in permanent tension with the external world. Those of his poems that provocatively dealt with sexual violence caused a scandal, which he had to account for before Paris's criminal court. The waves generated by *Les Fleurs du Mal* turned dandyism into an object of interest for bourgeois society, which duly condemned it, just as the court had condemned Brummell's impudence.

The great theoretician of dandyism had already dropped out of bourgeois society by his early youth, having rapidly squandered his inheritance on hotels, bleached shirt collars, and forged artworks. Penniless, he soon descended into Bohemian Paris, an impoverished underclass composed of the destitute, prostitutes, petty criminals, and people with mental illnesses, as well as the emerging new type of artist who no longer served either church or king. Baudelaire plunged into this world, loved it, but never really belonged to it. Acutely aware of his status as an outsider, he turned it into a kind of act. While most of the inhabitants of Bohemia wore rags, he went about in an austere black velvet coat, drank cheap

liquor and ended his day by dining with bankers. As Walter Benjamin put it, "Baudelaire was a secret agent," one who moved like a fish through water. Having become destitute, he kept up an appearance of affluence despite the holes in his silk shirt. But while dandies embraced the illusion of being better off than they really were, many other Bohemians rejected it as bordering on imposture.

The determination of dandies to reveal neither their true face nor their actual poverty made many people indignant. More than anything, they wanted to tear the masks of inauthenticity to pieces. But what truth would be revealed behind them? Oscar Wilde, a dandy of the following generation, saw honesty as a false form of vanity, and recognized the violence implicit in human authenticity. The Greek root of the word *authentéo* means to have complete power over someone. The noun *authéntes* did not only describe a master craftsman or builder, it also meant a murderer.

Against the tyranny of the authentic, dandies cultivated an artificiality that coalesced around an empty center. The absence of an essential self appeared not so much a loss as an opportunity. Instead of presenting an authentic personality, filled with a genuine ego, they took on the role of shop dummies which changed their own clothes. In this respect, they resembled those "bodies without organs" described by Antonin Artaud in his *Last Writings on the Theatre* (1946). While incarcerated in a psychiatric clinic, Artaud had a mysterious vision of a hollowed-out body, whose inner world could no longer be fastened to the strands of its own desires. This emptiness was supposed to restore to him the freedom taken away by society's institutions.

In the dying neoliberalism of the early 2020s, the body without organs, which keeps its contents indetermi-

nate, seems out of fashion. In the current authoritarian atmosphere, attention is focused upon those doctrines that commend the self to pay attention to the voices of its body, while those celebrating emptiness as a key to autonomy are ignored. Instead of listening to his inner voice, the dandy prefers to look good. It was at this point that my train of thought was interrupted. The large window of the Migros supermarket on the other side of the street shattered into a thousand pieces. An excited crowd used the cycle rack it had turned into a battering ram to clear away the remaining pieces of glass. Then it stormed the interior of the shop. The first person to come back out was a lady who had been working at the post office counter just the day before. She was nonchalantly carrying a pallet of full-fat fresh milk under her arm.

The Milk Thief

"You have a wonderfully beautiful face, Mr Gray. Don't frown." The painter Basil Hallward, who paints Dorian Gray's portrait, says that it is only shallow people who do not judge by appearances. And yet it is the only thing really worth having. The true subject of his 1891 novel *The Picture of Dorian Gray* is the beauty of youth. In 1970, no actor could more consummately represent this than Helmut Berger. There is a scene in the film when, seeing his portrait for the first time, he looks deep into the eyes of his immortalized image. The painting reflects back to him the horrific truth that he will grow old, and therefore hideous: yellow crow's-feet, flaccid cheeks, his mouth "would gape or droop, would be foolish or gross, as the mouths of old men are."

Worse still was the threat of an inner ugliness. How could anyone bear that? Enraged, he curses his portrait: you should grow old, not I. From this moment, the spots and wrinkles of age begin to appear in the painted face, while he himself comes to seem eternally young, no matter how dissolute his life. To ritually seal this exchange of roles, Gray murders the painter. Just as the "Peter Pan syndrome" came to describe male daydreamers who appeared to wander untouched through life, the term "Dorian Gray syndrome" came to stand for those who suppress the signs of their own mortality.

When the novel came out, many insiders thought they could recognize the artist James Abbott McNeill Whistler in the figure of the murdered painter, since they knew how much he worried about his canvases aging. However, Whistler had mainly become famous for suing those who criticized the high prices of his paintings. The artist, who famously argued that a mark made with the flick of a brush required a knowledge gained in the work of a lifetime, used to sign his paintings with a drawing of a butterfly. Since Whistler belonged to Wilde's circle, the winged creature became a symbol of dandyism, lending it a new connotation. Since the middle ages, popular superstition had associated the beautiful winged insect with the physical transformation of witches into animals. These creatures would seek to steal the *Schmetten,* or thickened cream that formed on the surface of milk, which is why the *Schmetterling,* as it was known in German, was often described as a milk thief; it is also why in English it is called a "butterfly." To this day, our language is still haunted by the notoriety of the women who changed into animals with unnatural abilities, and wanted nothing more than to skim the cream. Many thought of the dandy in similarly disparaging terms, as a cat who'd

got the cream, or who had adopted largely feminine accomplishments in order to obtain what the *crème de la crème* had forbidden him. Unlike witches, dandies were not burnt, but there were fantasies of violence directed against them. Cartoons showed regiments of dandy-baiters rampaging about, pretending to kill them off with oversized poison syringes.

Oscar Wilde looked nothing like a butterfly. He had no dainty wings to flutter; there was, if anything, too much of him: over six foot tall, and graced with an elongated head and a face that simply begged to be punched. The corpulent giant gave interviews and went on a lecture tour of the United States, thereby reaching a wide public. As an entertainer with a somewhat dubious reputation, he had to make a lot of noise in order to sell himself. Even more than Baudelaire, Wilde was known for his eccentric gestures, having once even prayed to sunflowers in public. Everything about him came across as larger than life and bordering upon caricature. Although in many ways he was not a dandy at all, he remains to this day closely associated with dandyism. Wilde's contradictory performance became the very epitome of the figure. And it wasn't only his appearance that seemed paradoxical; the older he became, the more paradoxical his behavior appeared. The preacher of the life of indolence got up every morning at half past four, lit his first cigarette of the day and started work. He then set about laboriously dismantling whatever Victorian society hypocritically affirmed as truths, and reassembling these into something else. He played with the truths of his time, preferring to deny them rather than let them oppress him.

Wilde loved lies and playing with deceptively true appearances. If everything could also mean something else, that might make life more fun. In his 1891 essay

"The Soul of Man Under Socialism" he played the political activist, who wanted to share everything with everyone. Later he became a satanist. Like a zombie Pinocchio, he investigated the possible truths about who Oscar Wilde might be. Sleeping in front of a mirror, constantly watching himself as if he were someone else, one thing seemed clear to him: that it simply wasn't possible to live the life of a dandy, for dandyism involved an idealized approach to life which belonged to the pages of literature. Instead he became a kind of somnambulist of dandyism, managing even to dramatically stage his own death in a hotel in the Rue des Beaux-Arts in Paris. It was the end of many years of persecution, which had begun with a transgression caused by forbidden love. The guardians of the law called it sodomy, and in 1895 Wilde was sentenced to two years in prison. As if that wasn't enough, the prisoner, who had no way of paying his debts, was also hauled before the bankruptcy court. Those in power wanted to destroy him. Wilde was not only a homosexual, he had also broken the terms of the social contract that prescribed how far artists could go. Now his enemies wanted to wipe him off the face of the earth. During his life, Wilde's books had won both acclaim and condemnation; after his death, they disappeared from the shelves.

Sublimely Bad Taste

Books disappear, words disappear. Time gnaws away at them till nothing recognizable is left. Some rise again to the surface, while others remain at the bottom of the sea of language. Camp was just such a word; in the last century it fell out of use with the rise of the Internet. Until it disappeared, camp described a playful engagement with

sublimely bad taste. On the Internet everything was now as tasteless as water, since processors make no distinction of content. Computers are only interested in quantities of data. Moreover, the net quickly became a dumping ground for the vulgar, the obsolete, and the arcane, as pornography and a new kind of flea market became its great success stories.

In the analog world, camp had resembled those adolescents who enjoy upsetting their parents by subverting their values. However, camp was never simply about opposing things for the sake of it. Sublimely bad taste turned a fond eye upon detritus, to things neglected because they were old, ugly, or useless. Camp also glorified all things that were overlooked for their utter ordinariness. In this respect it took up Wilde's idea of an assault on cultural hierarchies, which he'd set out in his 1891 essay "The Critic as Artist." This involved a literal indifference, which applied the same attentiveness to pre-Raphaelite paintings as it did to the crisp coating of a breaded schnitzel, opposing the equality of the beautiful to the arrogance of the upper classes. Camp, however, did not just regard everything with a literal indifference; it could become excessive and hysterical in its love of exaggeration and its aggressive flirtation with kitsch. It was tastelessness—precisely what seemed the opposite of the dandy's attitude towards life—that broadened its range of expression. The old order tried to preserve its power by means of the dubious rules of good taste; camp twisted these into a secret counter-knowledge, whose dynamic remained largely inaccessible to outsiders.

Camp involved a kind of aesthetic conspiracy. Such opaque agreements pose a danger to the existing order. Every revolution begins with a conspiracy, which is why in times of crisis this key to change is considered particu-

larly dangerous. Camp's opaque conspiracies, which declared ugly things to be beautiful, never formulated a method that could be learned, in order to avoid coming under any kind of control. As a result, the subtle distinctions of complex taste, whose obscurity resists any clarification, are accessible only to those with the vaguest awareness of the aberrant character of their own behavior. Those who had actually understood how the game was played were generally unable to make use of its stratagem of taste. Though it might sound like a fable of lost innocence, of Paradise and the Fall, most attempts at deliberately being camp lacked the nuance of being right when they were wrong, and amounted to little more than stale irony.

There are various theories about the linguistic origins of camp. One is that it derives from the French term *se camper,* a pun that denoted an exaggerated posturing. The first use of the term in English literary language was by Christopher Isherwood in his 1954 novel *The World in the Evening*: "You can't camp about something you don't take seriously. You're not making fun of it; you're making fun out of it. You're expressing what's basically serious to you in terms of fun and artifice and elegance."

Ten years later, Susan Sontag took up the term in her 1964 essay "Notes on 'Camp,'" which characterized it as a lived contradiction of sympathy and revulsion. Camp, she wrote, refers to a love of exaggeration and a search for lies that express the truth. Sontag's engagement with camp, the technique of the inauthentic, coincides with American literary theory's discovery of the term *postmodernism*. Both attempts at describing contemporary currents of thought had recourse to artistic ideas of the previous century. As early as 1870, the British painter John Watkins Chapman had used the term "postmodern"

to describe the dawn of an age that would follow the modern one. Similarly, the discourse on camp had its origins with his contemporary, Oscar Wilde, to whom Sontag dedicated her "Notes on 'Camp.'"

Expect Nothing, Enjoy Everything

Nowhere can one find the Truman Show more serenely performed than in the cantons of the Swiss Confederacy. In the towns and villages between Zurich and Bern the oppressive haze of the coming catastrophe can be blithely ignored. Rolex and the National Bank will sort everything out, while the soundtracks to *Solyent Green* (1973) and *Armageddon* (1998) alternate in their Deep House versions. The complacency of the Swiss was always mildly repulsive, but it had its own crazy charm too. There is also something not entirely misguided about an attitude that ignores crises and imminent wars in favor of taking a warm bath. If there's a lot this attitude ignores, it does at least refuse to maintain any illusions.

The dangers cannot be swept under the carpet, but I can view the situation like a dandy who sees the world is falling apart and concludes that he couldn't care less. I am so far from not caring that I have to protect myself. My indifference is a form of defense. It doesn't just protect me from being paralyzed by fear, it also protects me from those who try to use the threat to control my behavior. Crises have always been a means of stoking fears, offering an opportunity to authorities to reshape a panicked society for their own ends. In such times, it seems necessary to cut myself off from my feelings in order to keep a clear sense of what is going on.

Although there is much in it that is familiar, the specificity of the current crisis cannot be denied. A number of different historical developments are coming to an end. The epoch of neoliberalism, which began half a century ago, appears to be on the way out. What seems even more crucial is the end of the hegemony of the West, of those powers that long believed they could dictate what

happened in the world, and what mattered. Europe will not collapse all at once; rather it will undergo a period of decline in which the old world falls apart while the future remains unresolved. There is also, on the empty horizon of the future, the prospect of an imageless utopia. But in the shadow of an inexorably approaching ecological catastrophe, which seems avoidable only by the outbreak of a nuclear war, it is difficult to muster much hope for it.

The current state of disorder in which we blindly hurtle towards an unknown future is reminiscent of the *fin de siècle*. In that epoch's state of shock generated by the Second Industrial Revolution, dandies moved against the approved current like drivers going the wrong way down a one-way street. The smooth surfaces of their vehicles reflected the oncoming traffic like an enigmatic dream image, as if the desert sky had turned into a pool, which disappears as soon as you approach it.

By looking to the dandy—and his history of dressing in elegant rags in decadent times—we can open up some room for manoeuvre; when faced with the possible collapse of our world, we can avoid looking like abject whiners, which merely serves the current authoritarianism. A dandy does not defend property or privileges. He finds conflicts over the distribution of goods distasteful. Any kind of war, even a war of liberation, seems to him an affair of the benighted, who don't realize that the only point of putting on a uniform is to look good in it. As an ascetic, he was always in favor of less of everything, and opposed to any claims to novelty, which generally proved to be little more than advertising for a new product. For him, social collapse sets the scene for an ominous catwalk which celebrates a journey into the unknown. He doesn't ask how he wants to live; he lives, albeit with a melancholic air.

As the old order collapses, the dandy makes no claim to be leading an exemplary life. He proposes no solutions, and denounces nothing as false—since he makes no declarations of any kind. He simply plays a different game. But the equilibrium of his game with the world's prevailing truths is under threat.

My Little Tower Won't Stand Up

Joris-Karl Huysmans's 1884 novel *À rebours* (*Against Nature*) tells the story of the fall of its main protagonist. The book appeared two years before the French journal *Le Décadent* first used the term *fin de siècle*. The scion of a degenerate noble family, Duke Jean Floressas des Esseintes, is an example of the sinister dandy, who seeks in deviance a means of attaining the exceptional. Little by little, he starts to lose his feel for the thrill of transgression. He miscalculates when he invites people to a *dîner de faire-part d'une virilité momentanément morte*. The black dinner held to mark the onset of his temporary impotence might shock the sensibilities of his contemporaries, but no dandy would have made public intimacies of this kind. Was this a case of giving a twist to the figure of the dandy? Or an attempt to deliver it a death blow? At the rowdy dinner, black women serve black turtle soup on black-rimmed plates. On the menu are also:

Dark rye bread,
Black olives,
Caviar,
Mullet botargo
and Black-heart cherries.

Hungover the next day, Des Esseintes is plunged into self-disgust. Unable to bear the sight of others, he flees to the seclusion of the city's outskirts. Cut off from his public, he loses himself in a hall of mirrors and becomes what a dandy should never be: an eccentric loner, cultivating his own ecstatic truth. His retreat from the world is a reminder of what happens to art when it abandons the social world in favor of profound seclusion: everything becomes innocuous. In the absence of any disturbance, tension disappears. Recluses lose themselves in subtleties. The isolation of the countryside rarely produces good art.

Des Esseintes resorts to cultivating orchids. Throughout the house, the air becomes thick and replete with scent from the heavy blooms. The light acquires an eerily greenish tinge, as if it were filtered through an aquarium. The plants grow profusely across the room, putting out obscenely fleshy leaves and stalks that look like the freshly washed fingers of corpses.

Zombie naturalism, which in the bourgeois interior turns introspective, formalizes a new type of dandy, one who mechanically distorts all social conventions. An automaton mind emerges from behind a machine-like mask. In place of the bourgeois notion of a human personality, the inauthenticity of aestheticism is revealed, which mechanically does the opposite of what is considered an acceptable way to behave. For example, a giant turtle has to die, collapsing from a heart attack under the weight of the precious stones inlaid upon its back, and all because Des Esseintes had decorated the animal to set off the colors on his oriental carpet. This sounds cruel, but in its damaged blindness it also opens up doors to a future.

Shut up in his curtained-off room, Des Esseintes asks himself from sheer boredom: hasn't everything already

been said and done? In so doing, he comes across as a precursor of the movement of great disillusion in contemporary art, which eighty years later—traumatized by the technological excesses of World War II, the atom bomb, the gulags, and the Shoah—would seek to find a way out of the ruins of industrial modernity by taking a self-reflective turn. Of all Des Esseintes's transgressions against nature, one in particular prefigured this distant future: a process of searching that neither believed in a better future nor hoped to convert others to it, and that moved about blindly in an unfathomable darkness. For Des Esseintes, flying blind inside his room only worked for a while. The energy behind his forlorn rebellion against the truths of his time soon starts to run out. He becomes weaker and weaker. As a cure and as his only way out, his doctor advises him to return to society. Although he takes this advice, it is already too late.

Until the publication of *À rebours,* Huysmans had lived a double life as a mid-ranking civil servant and an author of scurrilous journalism; after it, he began to move away from dandyism. He found himself drawn to the Catholic faith and medieval mysticism. There followed a series of monastic retreats, and further abysses opened up. The irate petty bourgeois now scarcely made any secret of his antisemitism. Following a trip to Hamburg, he described the commercial city as a gigantic "nest of Jews." What emerged with Huysmans was a dandyism turned reactionary by its fury with a moribund present. A similar attitude is to be found in the student who recently performed the artistic action *Mein Türmli* (*My Little Tower*). The young painter from Ticino stole a Cessna airplane from an airport in northern Switzerland and flew it into the middle stories of Zurich's University of the Arts. This was after his funding application to the

City of Zurich's culture department for a scaled-down re-enactment of the attack on the Twin Towers had been turned down. Some gave him credit for at least phoning first to let them know he'd be doing it anyway. But since no one believed him, the disastrous repeat performance went ahead.

Spiralling Inwards

Shortly after *Against Nature* came out in 1884, an ardent admirer, Paul Valéry, wrote a sequel to it, the novella *Monsieur Teste*. It was not published, however, until 1927, over forty years later. Monsieur Teste represents a new, unprepossessing type of dandy, who contrives to switch masks in a "play of personalities" that is almost invisible. While he assumes various different identities in his performances, he walks about the streets of Paris unnoticed, disguised as a modern Everyman. While Des Esseintes is involved in constantly changing his interior furnishings, Teste confines his experimentation to thought alone, turning his mind into a "bordello of possibilities." However, he shuns any intimacy with his thoughts: instead, he coolly watches them. Teste, whose name is a pun on both *tête,* head, and *testis,* testicles, watches his own mind intently, observing the demon as if it were someone else's.

Teste's life is almost entirely conducted within this dim conceptual vault. It prefigures what Michel Foucault would later call a heterotopia: a diffuse interior space that shuts out most of the external world, thereby opening up possibilities for life to be organized according to self-determined rules. Unlike for Des Esseintes, this mental autonomy, this anarchism of the mind, has no need of material objects. Instead of reclining in a green-

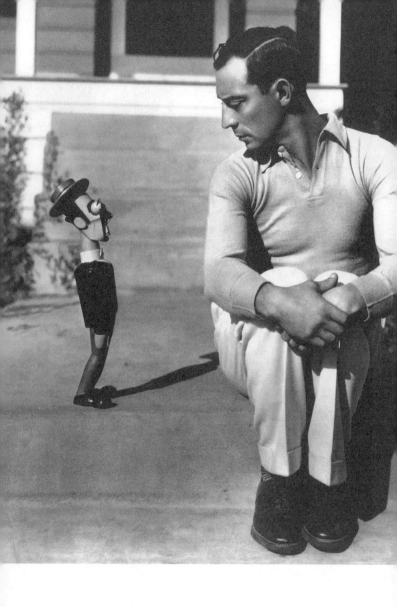

house full of lushly overgrown orchids, Teste rattles around inside a bare apartment. Empty spaces lend themselves to the study of the movements of thought. While the ascetic closely observes his thoughts, he casts an impassive gaze on his surroundings and lets things take their course. He passes no judgement. He makes no criticisms, and has made it a rule to have no opinions about anything. What would they be, other than "ingrained conventions that one would never invent oneself"? Teste remains an observer who seems indifferent to everything. Revulsion of the kind felt by Des Esseintes is alien to him. Self-observant, he does not actually want to approach his self; rather, he reflects upon himself in order to keep himself at a distance. The point of such self-distancing is to escape one's own predictability. Instead of the boredom of a stable identity, he wants to be surprised by a stranger. He seeks to vacate himself in order to be able to control himself, rather than be manipulated by others. His desire for autonomy through self-control is especially focused on his nerves, since they are in constant control of his body. Here the text becomes biographical. Its author, Paul Valéry, suffered from severe neuralgias. To gain control of what was happening in his body, he uses the text to grasp at the nerve fibers where the pain is located. He then organizes what he grasps like the limbs of a puppet on a string. But the puppet master cannot control the marionette. When Teste can barely stand the pain any more, he separates his two selves so violently that the puppet finally ends up lying motionless on the floor. As if speaking of an unknown third party, Monsieur Teste confirms that he has killed the marionette.

Valéry started writing his story as a teenager in 1886. By the time the fragments finally appeared in 1924, the author was already fifty-three years old. Like an

inverted flashback, *Monsieur Teste* tells the story of a version of the author that he has projected into the future. In his character, the young writer had sketched out his future life project. For almost half a century, the author observed the slightest movements of his thoughts and of the body that was attached to them, writing down every day what he thought, breathed, and digested. Over their thousands of pages, his *Cahiers* constitute a log book of observations of all the movements and emotions that a human being and his demons might have.

Until this point, the dandy had drawn all attention upon himself; now in this altered state he attempted to become a blank space. Valéry writes, "There is no sure likeness of M. Teste. Every portrait of him differs from the others. The man with no reflection: the ghost who is our *self*—which he *feels he is*—and who is clothed with *our* weight."

Apart from *Against Nature,* another inspiration for *Monsieur Teste* was a thought experiment in theoretical physics known as the Maxwell Demon: an invisible spirit with the ability to see gas molecules and to arrange them in order of their temperature. The phantom tries to formulate the impossible wish of turning itself into a perpetuum mobile, a machine that can exist independently of any energy source. *Monsieur Teste* translates this into the notion of the possibility of an autonomous personality. The mysterious Teste, whose inconspicuousness makes him invisible to others, who scarcely has need of anything in his bare apartment, and who strolls through the labyrinth of his thoughts like a mechanical marionette, would become a catalyst for many things: he anticipated Roland Barthes's "Death of the Author" by many years, he appeared to foreshadow institutional critique in art, and produced one of Oswald Wiener's keys to artificial

intelligence. Teste could also have been a preset for Kraftwerk's 1978 dandy hit, "The Robots."

"We're functioning automatic /
And we're dancing mechanic"

Around the *fin de siècle,* the figure of the dandy had coalesced around a subtle mechanicism; a few years later it would become a means by which the next generation of dandies sought to escape themselves.

Becoming a Machine

Paris, July 6, 1894. On the sunny terrace of a restaurant, the waiter served the stockbroker a glass of ice-cold champagne. He drank it in a single draft and keeled over dead. The heart attack left his seventeen-year-old son half-orphaned, and with an immense fortune at his disposal. This did not make life any easier for the young Raymond. But what do we mean by "easy"? His childhood in a grand house on the Boulevard Malesherbes, with Marcel Proust among his sweet little playmates, was a long trek through a frozen landscape. Roussel had learned early on how to escape, either into the labyrinths of his books, or into certain restaurants whose rituals offered moments of security, such as when the waiters cracked open the oysters or pounded the *tartare de boeuf* with a spoon in a wooden bowl, as if it were a drum.

By the time he reached adolescence, the voices of those who regarded his passions as unnatural were growing ever louder. The fact that he was not free to be who he was left him with deep wounds. He might have used his inheritance, which amounted to about forty million francs, to comfort himself with the usual luxuries of the rich. Although he had his suits made at Johns & Pegg in

London's Bond Street, and although his bachelor life was untrammeled by commitments, he was left feeling empty. To escape this void, he took refuge in a "realm of ideas," designing a thirty-foot-long car. This mobile machine for living in was built by the automobile company Lacoste. Roussel's house on wheels allowed him to keep reality at a distance. Heavy curtains were kept drawn across the windows in the rear part of the caravan. He listened to the world outside through the radio.

When he appeared in public, it was generally with a young woman at his side. She called herself Charlotte Dufrène, but her real name was Marie Charlotte Frédez. Raymond's mother had hired the social columnist to ease her son's loneliness. However, the true purpose of this gesture of maternal love was to conceal her son's sexual inclinations. He should not be what he desired. Despite these awkward beginnings, Roussel and Dufrène developed a lifelong devotion to each other. However, their relationship was not entirely free from tensions. He would repeatedly try to withhold things from her, omitting to show her his inventions, or setting off on his own without her—small attempts at escape, for which she punished him with further demands for money.

Roussel could afford to live the life of a dandy author, writing what he wanted. All the same, the fact that very few of his books sold cast the young writer into a profound crisis. Not only his sexual desires, but even what he wrote—all of it was wrong. After withdrawing from writing for a while, he took up his pen again as someone else. His texts now struck a different tone. They developed fantastical stories out of found sentences, advertising slogans, and newspaper reports. Roussel no longer wrote, he manufactured texts out of other texts. He had himself replaced by an imaginary machine,

which arranged letters with the iron hand of a body without organs. No one could now reproach him with having written a bad book. *He* hadn't. The writer he had once been was transformed into a writing machine. This transformation was a form of self-dissolution, something that Roland Barthes would later describe, in his 1967 essay "The Death of the Author," as the conversion of the authorial voice into writing; according to him, it was "that neuter, that composite, that oblique into which every subject escapes, the trap where all identity is lost, beginning with the very identity of the body that writes."

Despite the ambiguity of his own role in producing them, Roussel liked seeing his name on the covers of his books. Since no publisher would publish his experiments in writing, Roussel brought out the texts himself in limited luxury editions. He also had cheap editions printed in softcover, which sold like lead balloons. During his lifetime, this author who claimed to be a machine was only read by a small public, but one that admired him all the more for his obscurity. Above all, Roussel's novels *Impressions d'Afrique* (1910) and *Locus Solus* (1914) were held in particularly high regard by artists who would go on to engage further with them. Their influence upon the development of contemporary art can scarcely be overestimated.

Roussel's body did not travel to Africa. Reality was not what he was after. Everything went on inside his head. Although he kept notebooks on his travels, these only ever marginally influenced his books. Hardly anything he actually saw went into them. It was not he who described the unknown continent—rather, the machines he invented, a system of rules and distortions, raised strange visions from the sea of words. Verses (*vers*) became worms (*vers*), whose double meanings produced other

worms, constructing a universe alongside this world. To many people, this was escapism. But the text factory inside his head was more a form of self-control. A strict set of rules replaced the self.

One person who sensed which doors Roussel had opened was Marcel Duchamp. In 1912 the young painter and his friends attended a theater performance of *Impressions d'Afrique* organized by Roussel himself at the Théâtre Antoine in Paris. Duchamp recalled: "It was tremendous. On the stage there was a model and a snake that moved slightly—it was absolutely the madness of the unexpected." That evening was to become a key experience for him: "I had the feeling that a painter could be better influenced by a writer than by another painter. And Roussel showed me the way." This influence became a bridge by which the Dandy system passed from literature to the visual arts, which it would then go on to completely transform.

While Roussel wrote with the aid of imaginary machines, he delegated the illustration of his texts to a human being. He did not give the draughtsman he employed full passages of text. Sometimes he'd send him a single sentence, sometimes just a single word. To maintain his anonymity as employer, Roussel hired a private detective who organized the delivery of these instructions. Behind this secrecy was a method. During his lifetime, Roussel kept the process by which he produced his texts secret. Although he wrote a kind of instruction manual to be published after his death, it led only to further mysteries. *Comment j'ai écrit certains de mes livres* (*How I Wrote Certain of My Books,* 1935) kept the true nature of the text generators obscure, allowing the author to disappear behind his masks.

By 1932, Roussel had decided to let his machines produce their last lines. The machine operator handed himself his own redundancy notice. From now on, the dandy just played chess, snorted mountains of cocaine, and drank champagne as other people drink water. Despair drove him to indulge in excess, as if he wanted to die as soon as possible from the heart attack that had killed his father. In the summer of 1933, Roussel moved into the Grand Hôtel des Palmes in Palermo. Charlotte Dufrène accompanied him to this icon of luxury from the Belle Epoque. She was in the room next door when, late in the night of July 13 to 14, he was found dead in room 224. Whether it had been an accidental overdose or a deliberate act of suicide was never clearly established. The inspector in charge of the case did not care what the rich junkie had died of.

To prevent himself being buried alive, Roussel had had a clause written into his will stating: "I absolutely insist that my wrists be cut with a deep incision so that I am not buried alive." But his executors didn't build the tomb in the shape of a library room which Roussel had designed years before. Nor did any of his relatives avail themselves of the thirty-two places he had set aside for them in his crypt. Even in death, Roussel remained a loner.

Lazy Breathing

Marcel Proust wrote in a letter to Roussel, "You have tremendous staying power, which is rare today, and can write a hundred verses without drawing breath where others manage ten lines." Marcel Duchamp was also fascinated by breathing in an alternative system to air. As an artist, he tried to add as little weight as possible to the

world. He did not reproduce. But the little he did do set off an endless series of discussions which he in turn helped to fuel. His strategy for maintaining this almost alchemical process of making much out of nothing consisted in hiding the motives behind his own behavior. Here, one of the basic rules of the dandy, never explain yourself, unfurls to create a whole universe. Duchamp's resolutely deadpan manner ensured he remained inscrutable to those who sought meaning in or explanations for his output. If the chatter caused by his secretiveness turned to murmuring, he would say: "let the little birds have a pee." This was not meant disparagingly: he liked birds, especially parrots, as he did the call of nature and having a laugh. What lay behind it was a determination never to aggressively impose his own views. Duchamp wanted to live his life without inflicting upon others his own taste, which was merely one opinion among many. Highly self-controlled, he spoke quietly, did not drink, and ate very little. Not only did he come across as somewhat ascetic, he often barely seemed to be present at all. Instead of setting himself up as someone who breaks rules, he disappeared behind what other people were saying about his work. His silence seemed to say: it may be that I did that, but mostly I do nothing. And then he'd add: I am breathing, you don't need to do much more than that.

For Duchamp, becoming someone who breathes meant rejecting all the little rules and warnings "which say you'll have nothing to eat if you don't show you're productive or working in some way or another." Duchamp's refusal to work articulated a no, but still more a yes to life. Following his great success at the 1913 New York Armory Show, which could have launched his career, he said yes to something else. Instead of becom-

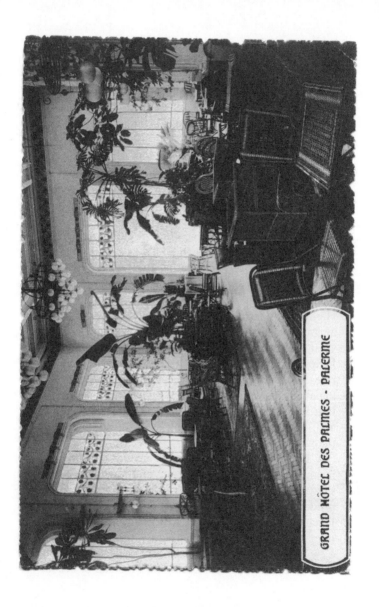

GRAND HÔTEL DES PALMES - PALERME

ing a success, he turned his back on the ambitious and hardworking who, by announcing what they intend to do, are always asking for money. Duchamp upended the idea that artists are under an obligation to create, or that they owed anything to the public: "The way I live does not depend on what others say about me. I owe nothing to anyone, and no one owes me anything."

Duchamp's determination not to fulfill anyone's expectations was strengthened by his reading of *The Right to Be Lazy* (*Le Droit à la paresse,* 1880), a slim treatise against the love of work, that "addiction which brings misery both to the individual and the masses." The polemic's author was Paul Lafargue, a young writer who sensed that his father-in-law Karl Marx's idealization of work had brought calamity upon the world.

Inspired by Lafargue, Duchamp planned a hospice for the lazy, but never put his plan into action. Instead of envisaging an institution where people can die better free from work, he worked on the idea of the readymade, which was the term used by American industry to refer to goods produced in finished form. Duchamp developed it further and devised a lazy method of producing a readymade. It involved a process of misappropriation, not unlike Brummell's use of champagne bubbles to polish his shoes.

Defamiliarizing mass produced objects offered the artist an opportunity to do little or nothing: in order to liberate them from their everyday function, take them out of their traditional context and turn them into artworks, he barely had to lift a finger. He called this asceticism a work without an artist. His refusal to be the person behind the work was a scandal that initially attracted very little attention.

Prefabricated products gave Duchamp the chance to disappear behind anonymous objects. He claimed to have no idea what he had succeeded in doing, as if he had had no part in making them: "If I have practiced alchemy, then I've done it the only way it can be done today: by not knowing what I'm doing." He already knew how to maintain an appearance of cluelessness over an extended period of time. One day he'd say: "You choose an object that you feel indifferent towards." The next he'd claim that the snow shovel he'd hung from the ceiling of his studio in New York was the most beautiful thing he'd ever seen. Every time he contradicted something he'd said earlier, it produced a wave of new interpretations. This practice of constantly reviving the discussion he sometimes called magic, and at other times negation.

By illogically forgoing any opinion of his own, Duchamp came up with another alteration in the dandy, which since Baudelaire's image of the sleeper in front of the mirror had been made subject to an endless game of Trap-the-Cap between himself and his reflection in objects: "My aim has always been to get away from myself, although I knew very well that I was using myself to do this. You could call it a little game between *me* and *myself*."

But by this point there were a lot more people involved in the game: Duchamp had turned himself into a multiple personality. As a young man, he had already started blurring his identity, assuming an increasing number of names. Since then he had also been known as Totor, Morice, R. Mutt, Marcel Dee, Duche, Rrose Sélavy, Stone of Air, Marcel à vie and Marcelavy. One of the reactions to Duchamp's version of this game of *Je est un autre* was to try to interpret the names of all these people. Thus, for example, the art critic Rosalind Krauss thought that the signature "R. Mutt" on the urinal was an allu-

sion to the German word *Armut* (poverty). But was she right? Or did the R. stand for a supposed Richard Mutt from Philadelphia, if not subliminally for "rich art," a reference to moneybags? The unanswered questions were part of the charming effects of the game, which seduced others into playing it. Since the readymades could be produced at very low cost, Duchamp had a lot of spare time, and used it to design perfume bottles or, like Roussel, play chess. He got better and better and eventually participated in the Olympic Games in Paris, The Hague, Hamburg, and Prague. With chess as with the readymades, it was a question of working out all the problems in advance. Both are procedures that require a capacity for sustained abstract thinking, and the players have a constant mental model of their moves and the possible reactions to them.

Another of Duchamp's doublings, his female alter ego Rose Sélavy, made the object *Fresh Widow* (1920), and in doing so showed more of the influence of Roussel than Duchamp would have dared exhibit under his own name. Unlike many of the readymades, he—or rather Sélavy—hadn't simply bought the fresh widow; rather he had commissioned a carpenter to build the mock-up of a window according to his own design. In this work, Rose, the later Rrose Sélavy, developed what Roussel had begun with the illustrator, anticipating the practice of conceptual artists hiring assistants to make their work for them, in a dandy-like depersonalization. The opaque window appeared to anticipate the reclusive life that Duchamp would later lead, first by himself, and later with his wife. After World War II, the couple lived in an anonymous brownstone on an unremarkable side street in Manhattan. In the living room hung a small Matisse and a large Miró. However, few people ever got to see them.

They lived like sleepers in a spy thriller. By the summer of 1963 it was all over with this kind of life. Marcel Duchamp's discovery in the United States began with a show at the Pasadena Art Museum entitled "A Retrospective Exhibition." However, instead of preparing to be received as the godfather of the American dandy, Duchamp and his wife Alexina went on holiday to Palermo. On June 4, 1963, the two of them arrived at the Grand Hôtel et des Palmes. The hotel where Raymond Roussel had died seemed to be the right place to prepare for the arrival in the present of his science fiction art of the past.

World as Game, Never Work

While the Duchamps were holidaying in Sicily, a letter arrived at the offices of the journal *Internationale Situationniste* in Paris. It had been sent by a postcard manufacturer, Louis Bouffier, who accused its editors of having reproduced one of his images without his permission. The photograph showed the wall of a house, on which had been scratched the words *Ne travaillez jamais.* The editor replied by return of mail: I wrote the words "never work" on the wall of a house in the Rue de la Seine and am therefore to be considered the author of the image. As far as he was concerned, this was the end of the matter. Bouffier would not be the last person to complain about Guy Debord's casual attitude toward intellectual property rights. Instead of writing anything himself, he would often appropriate other people's texts and play with their content. In his own way, this ambitious man was lazy; and playing games was the activity that seemed to him least like work. But what is a game? In theory it is defined as a separate space where players move according to their own rules, allowing a parallel world to emerge. This parallel reality allows us to treat the existing world playfully, and to become for a while someone else. It is a temporary freedom, since the players know that it will eventually disappear again. The situation's finite nature creates the conditions under which you can, for the duration of the game, exchange the person you think you are for someone else. In this temporary state of "being someone else," Debord saw the possibilities of a revolutionary politics. For this reason, he didn't just play existing games; he thought up others hitherto unknown. In the mid-1950s he invented a board game called *Jeu de la guerre,* which translated the military variables of ter-

rain, troop forces, and speeds into a table-top conceptual model. Unlike other games of strategy, the object of the game of war is not to surround territories or to checkmate your opponent's king. The object is to annihilate the enemy. By which the *Jeu de la guerre* meant the Society of the Spectacle. In an abstract rehearsal for the coming insurrection, the players had to cut the communication lines by which their opponents directed their forces. If they succeeded in severing one of these, it generally meant the beginning of the end for the army. A general who can neither communicate with nor issue orders to his rank and file loses control over their combat effectiveness.

Debord's militant baby, a rectangular game board composed of twenty-five squares by twenty, would occupy him for half a century. In 1965 he took out a patent on it. It would be another twelve years before he and his friend Gérard Lebovici set up a company to produce a 45.4 × 36.5 cm luxury edition of the Game of War in a quadripartite edition of silver-plated copper.[1] One of these became a central prop in his 1978 film *In girum imus nocte et consumimur igni*. The game's appearance in the film, whose title can be translated as "we wander in circles at night and are consumed by fire," made it a central part of

1 Gérard Lebovici's interest in the Game of War might be attributed to the fact that had to learn early on how to survive in a hostile environment. He was left half-orphaned as a child, after Germans murdered his mother in a concentration camp. After the war, Lebovici wanted to become an actor. However, his father's death forced him to give up his acting studies. He returned to film by a circuitous route, this time not as an actor, but as an agent to Catherine Deneuve and Jean-Paul Belmondo. The success of these discoveries gave Lebovici an opportunity to live a double life. As a leading figure in the film industry, he would dance at parties given by the Parisian hautevolée, while at the same time financing the Situationist International and such openly militant anarchist groups as Action Directe. Alongside these clandestine activities, Lebovici publicly ran the publishing house

Debord's vision and a tool for the general uprising. It therefore became a game whose true object lay outside itself.

After Debord had worked obsessively for two years on editing the film, Lebovici, who was always ready to finance his friend's projects, rented Studio Cujas, a small cinema in the Latin Quarter. For half a year, all it showed was this film. A voiceover by Debord gave a commentary on its images. He began by calmly condemning society's symptoms of decadence, but soon switched to insulting his audience, calling them a bunch of idiots who could not expect the slightest concessions. Then he really let rip, only to say at the end: "Let's take it again from the beginning."

Drama of Indignation

At Studio Cujas it became obvious that Debord had lost contact with his inner dandy. His behavior no longer confounded people. He had become obstinate, and with it more predictable, and had lost the capacity to astonish. As a player, he seemed lost; as a revolutionary, his moment—May '68—was already behind him.

Champ Libre, which published the most important writings of the radical left. Apart from the canon of radical literature, it also published titles such as Jacques Mesrine's 1984 memoir *Death Instinct* (*L'instinct du mort*), which he wrote in prison. The gangster with many faces had made Bertolt Brecht's remark "what is robbing a bank next to founding a bank" the motto of his personal war against a corrupt society. Lebovici encouraged this dandy gangster, who would greet the police with champagne when they came to arrest him, to write his life's story. The autobiography of "France's public enemy number one" was a great success. In the winter of 1979, corks popped; clearly, however, one didn't pop fast enough, and the police shot dead the bestselling author. With his daughter left a half-orphan, Lebovici adopted her. He didn't have much time left. On January 7, 1984, the body of the fifty-

When he was still a dandy, he didn't just invent games and make disturbing films, he also saw himself as an instigator of scandals; for him, the Game of War was a training ground where uprisings could be rehearsed. He understood the infiltration of the enemy's communication system as a form of détournement. Redirecting the enemy's communication signals was one of the central strategies of the Situationist International in their struggle against the Society of the Spectacle. Signals were detached from their intended meanings, which were negated and then reinterpreted. Scandal, détournement as public theater, involved setting a trap that creates a situation where someone stumbles and falls, thereby initiating an uproar in the existing order.

For a scandal to be possible, there must be an attack on a line of communication by which—to put it in the language of the Game of War—the moral values of a society are transmitted. If it succeeds in capturing this supply route, the scandal can unfold its drama. Just as in theater, there is a cast of actors: the accuser, the accused, the victim, and the indignant onlookers. Initially it is unclear which side many of the actors are on. What is crucial is when and where everything takes place. The

one-year-old was found inside his car in a parking lot on the Avenue Foch. He had been killed by shots delivered at point blank range. For the French press, there was no mystery about this killing. The trail led directly to Guy Debord. The news magazine *Le Nouvel Observateur* invented the story that Debord had controlled Lebovici like a marionette. And when the puppet had threatened to turn off his money supply, the puppet master had killed him. Even the police officer who kept transcripts of his interviews with witnesses felt he was writing a poem he was too tired to finish. After Debord had finished the thankless task of removing the crudest inaccuracies from the official's half-finished sentences, he wrote a thorough account of how he saw the case, entitled *Considérations sur l'assassinat de Gérard Lebovici* (1985). What had actually happened in the parking lot was never properly ascertained.

explosive power of scandal depends on choosing the right moment for the attack. To generate a current of indignation, the object of the scandal must, as in fashion, touch upon something that is already in the air. The scandal plays itself out like a Greek drama: in the first act, the actors and their situations are established. Slowly the outlines of the scandal begin to be traced on stage. Suspicions pass across the communication lines between the various parties. As in a game of Chinese Whispers, the rumors become increasingly shocking. It is still unclear whether this is enough to create a scandal, and, if it is, who will be left facing the music. The chorus, the sounding box of indignation, still seems to hesitate.

In the second act, suspicion narrows. Complex processes are reduced to simple elements. The chorus must decide. Its singing grows louder. Public excitement grows at the prospect of the fall of a respected individual. It was precisely this envy that many dandies longed for, since, for a moment, it drew all eyes upon the object of the scandal. In this way too the dandy is somewhat schizophrenic: he doesn't want to attract anyone's notice, but at the same time desperately seeks attention.

In the third act, a key event occurs in which at least one of the accused falls. They are exposed, confess, and either withdraw from public life or commit suicide. A generally recognized authority can now pass the judgement with which the chorus of the indignant can concur. The outcry enables this chorus both to reassure itself and to defend itself against whatever threatens its own system.

In the fourth act, the chorus swells again unexpectedly. It is at this point that the question is decided: does the indignation serve to confirm established values? Or does the disruption lead to a break with the old order? Scandals that do more than merely refresh the moral bal-

ance are rare. What generally happens is that one of the actors changes their mask, and by the fifth act everything's all fine and dandy again.

While in Debord's time scandals might still have seemed like a potential political tool, their subversive power has since come to appear somewhat dubious. Donald Trump showed himself to be a virtuoso post-situationist. By quickly delivering a series of carefully aimed shocks, he managed to transform the chorus of the indignant into a regiment of stunned, open-mouthed spectators, who found themselves in a state of permanent indignation. However, Trump remained a pseudo-dandy, who claimed to be indifferent to everything, but who really cared more than anything about power. Trump's behavior very clearly posed the question: how can a scandal still have any effect in a society that is constantly intoxicated by scandal?

Today scandals appear to be just one of many strategies in the toolbox of elites that seek to rule by means of crises; they are part of the disruption management that has come to replace what was once called politics. I've nothing against making the world a better place, but, as a way of doing this, scandals are a two-edged sword, since indignation is necessarily based on the repetition of accepted moral principles. An unfamiliar insight that the public has not heard of before cannot generate a current of indignation. For the chorus to come in at the right moment, it must first be familiar with the punchline. This is why the only thing we are likely to find surprising about a scandal is who ends up playing which role in it.

As for art, there is scarcely anything it can still hope to do with scandal, given that this is not an open-ended process but rather a dynamic that knows its own arguments off by heart. From a political point of view, it sometimes

makes sense to know how something will work out, as a means of achieving an aim. But an art that merely repeats its static values has given up on life, and becomes a risk-free way of affirming established knowledge. This kind of scandalized reaction, which is fostered by cancel culture, assures itself of accepted truths, prefers to lecture others instead of broadening knowledge, and is therefore con-servative.

The Dice Always End Up Somewhere

At this point a group of young people emerged from the covered market in Zurich, where I had just been sitting. One of them was carrying a paper bag, which burst open with a pop, and a whole assortment of cheeses scattered across the pavement. It came as a shock when we realized that the bag had not ripped, but had been shot. The markswoman rode off on an electric scooter. On the back of her T-shirt I could just make out these words: Switzerland must die.

For a long time I thought it was wrong to live aimlessly. I would stare in amazement at other people with their plans, ideas, and convictions. They seemed to know exactly what questions to ask, and to have clear ideas about anything and everything; they could point something out and know where it was supposed to go. Even the kid sitting next to me in class would sketch out a route showing the way from thesis to conclusion before starting an essay, while my pen was racing haphazardly across the page. It wasn't just that I lacked the determination to stick to a plan; losing myself on an aimless adventure simply seemed far more appealing. As I wrote, I would fumble around for ideas, and the lines on the paper would guide my thoughts, rather than the other way round. Often they led me into vast realms of long-windedness; not infrequently, they got nowhere.

Were these open-ended meanderings what triggered my sympathy for the dandy? He too operates without a plan and heads off into the unknown. His tactic is to react to everything that is immediately possible. The dandy's aimlessness has often led to him being dismissed as a feckless *hasardeur.* This term, which derives from the French word *hasard,* chance, implies an attitude that does

not seek to force the course of things. In the nineteenth century, Stéphane Mallarmé, the poet and publisher of the fashion magazine *La dernière mode,* formulated a concept of the future as chance. His 1897 poem "A Dice Throw At Any Time Never Will Abolish Chance" ("*Un coup de dés jamais n'abolira le hasard*") can be read as a metaphor for the dandy's passive stance, that of a gambler who knows that, even when he does everything right, he cannot control the fall of the dice. So you couldn't expect him to make predictions about anything more than the best place to eat this evening.

Antwerp, summer 1964. The forty-year-old man gazed into the mirror and asked himself: is this really supposed to be my life? Then Marcel Broodthaers went out and wandered through the streets for a while. It was raining. He pulled up the collar of his trench coat. When he got to the Galerie Saint Laurent, the poet described to the owner his idea of inviting people to a show with the words: "The idea of inventing something insincere crossed my mind." The art dealer Edouard Toussaint liked his idea of basing an exhibition on a lie, and the two of them agreed a date for it.

Once he got home again, Broodthaers lay in bed for a few weeks. It was only when he was running out of time that he got up, picked up a copy of his badly-selling book of poems, and started making a mold of it from plaster and fabric. His beloved language games did not sell; by transforming them into a possible commodity which he hoped would sell better, he had come up with an artistic method that allowed him to interpret the rules of art differently. He was now playing a game with the rules. It was a game with both his own reflection and the conditions in which he found himself.

Like a dandy moving against the grain of his contemporary reality, Broodthaers did not support storming the palace during the high point of the May '68 uprising. Mumbling an incomprehensible poem, he simply walked in through its front door and declared himself the director of the imaginary *Musée d'Art Moderne, Département des Aigles.* In this castle in the air he decided, as if imitating one of Raymond Roussel's *procédés:* "I choose two almost identical words." Then he rewrote an old poem. "*O mélancholie! Aigre château des aigles!*" But what was this transformation of an "r" in to an "l" supposed to mean? Did melancholy inhabit the eagles' sour castle? Or was it rather a museum of vinegar, where high above birds turned circles over the queen of salad sauces squawking "vin-aigre-ette"?

Seven years later, in 1975, Broodthaers shot a two-minute film. Its working title was *Movement;* later it was called *Monsieur Teste.* The film took the verbal image from Valéry's novella *Monsieur Teste* literally, representing the careful observer of the mind as a silent marionette. In the fragment of film, the icon of self-observation is transformed into a wooden dummy, which shakes its head as it reads, almost as if a mute soloist were all that remained of Waldorf and Statler's wagging heads on the Muppet Show balcony. With no face to pull, the marionette mechanically absorbs the news magazine *L'Express.* Could it be that Broodthaers was making fun of those who disdained to hold any opinion, by making them look like grumbling gray nonentities?

Der Directeur du Musée d'Art Moderne, Departement des Aigles, weigerte sich, das van Laack Monokel zu tragen.

Natürlich bekommen Sie für den Preis eines van Laack Hemdes zwei andere.

Nur sind das eben keine van Laack Hemden. Den seidenweichen und glatten Sitz des Kragens, den vollendeten Schnitt und die exklusiven Dessins finden Sie höchstens noch bei Maßhemden. Der Stoff ist reine unverfälschte Baumwolle. Ein Hemd, das sich sehr angenehm auf der Haut trägt und sich – tropfnaß aufgehängt – in 7 Minuten bügeln läßt. Ohne die Vorzüge reiner Baumwolle zu verlieren.

van Laack Hemden gibt es von DM 38.- bis DM 118.-

van Laack

DAS
KÖNIGLICHE
HEMD

Eagle Over Activist

Düsseldorf, September 27, 1972. On this moring,
Broodthaers wrote to someone who rarely kept his opin-
ions to himself. A month later, his letter to Josef Beuys
appeared in the *Rheinische Post* under the title "Politics
of Magic?" Following the opener "Our relationship has
become difficult," Broodthaers drew a provocative com-
parison by ascribing to his colleague the role of Richard
Wagner. At documenta 5 that summer, Beuys had an-
nounced the establishment of the Organization for Direct
Democracy, and a few days later he and some students
who had been rejected by the Düsseldorf Academy of Arts
occupied its administrative offices. Broodthaers argued
that to challenge power in this way only lent it legitima-
cy; instead of playing the critical class clown, artists
should be making the case for an artistic language that is
non-identical with that of the world that governs our
lives. From this country of more autonomous language,
he wrote to the activist professor that in his attic he'd
found a letter from Jacques Offenbach to Richard Wagner,
from which he enclosed an extract. In his letter, Offenbach
distanced himself from Wagner's fantasies of a conver-
gence of art and power. This fictional conflict between
the two composers was intended as a metaphor for
Broodthaers's skepticism about Beuys's activism. The
latter's habit of reacting directly to social and political
events seemed to Broodthaers a terrible mistake, since in
his view it played into the hands of the powers that Beuys
was trying to attack. Broodthaers, by contrast, wanted to
prevent art from adapting to the order of the false totality.
He was concerned that, by recognizing its language,
Beuys's critical involvement would only emphasize the
reality of power, and his reservations have lost little of

their relevance. Nowadays, there are even more of these eager advocates of issues of burning relevance. They present a depressing picture of art as a form of paid criticism, which takes to a public stage to mend the flaws of the existing order. Nevertheless, to reduce Beuys's role to that of a rent-a-critic would be to do him an injustice.

Joseph B.'s Deadpan Expression

Düsseldorf, the first months of 1966. It was early in the morning, still the hour for breakfast and for discussing banalities, when a scruffy-looking man walked into the Autohaus Becker, a Düsseldorf car dealership, and announced that he wanted to buy a used Cadillac or Rolls Royce. Since they didn't have either in stock, the salesman suggested a Russian green Bentley S1, which had previously been driven by the banker Alfred Freiherr von Oppenheim. The customer liked the idea. Barely hesitating, Beuys paid 25,000 marks in cash out of his coat pocket, got into the car and drove home. The limousine meant that the forty-five-year-old artist could now command very different prices for his art from those he could get while still riding a bicycle. However, Beuys's style of driving—described by the journal *Auto Motor Sport* as "otherworldly, majestic and fast"—meant that the car regularly ended up in the garage. Every time it did, the artist was offered a hire car, which he refused in favor of travelling by taxi: "I can't just drive some random x of a car." The question remained open who this "I" was for whom no "x" was suitable. Every one of his gestures made a mark, but they also functioned like a mold where anything could find a place. It is no surprise that he once said: "My whole life has been an advertisement."

私はおいしいウイスキーを知っています

ユーゼフ・ボイス氏とはかつての出会いの友情のために応えた

自然はいつも沈黙したままです。大いなる自然は、太古から変わらぬ循環をくりかえしています。そこに、幾
十年、あるいはそれ以上の時間を呼吸し続けているのはニッカの原酒たちです。人の愛をいっぱいにうけた
原酒は黙したままに自然と一体となり、抱かれています。ニッカが北の自然を最も重視するのも、原酒たちが
から帰った時の至上のおいしさに感嘆するからにほかな
りません。スーパーニッカ(760ml)3,570円(標準小売価格)

NIKKA WHISK

74

Beuys's profession of faith in publicity is reminiscent of the relationship of the artist to his present time described by Charles Baudelaire in his 1863 work *The Painter of Modern Life*—and which, not surprisingly, begins with the dandy. He conceives of contemporaneity not as an engagement with current themes of his time, but as an attentiveness to the voids and surfaces of the present moment. To remain legible, aesthetics requires an external relationship to the present: "Without this second element, which is like the amusing, teasing, appetite-whetting coating of the divine cake, the first element would be indigestible, tasteless, unadapted and inappropriate to human nature."

Rather than seeking to express contemporary reality, art should build a bridge between its own parallel time and the now of the present. In order for this process of translation to work, Baudelaire called for the careful observation of the present, while resisting subjugation to it. Maintaining this distance meant the translators had to regard themselves as objects. Observing your own actions was the only way to keep a balance among the claims of the now, and avoid being driven about by the affects capitalism generated in you. Thus the dandy's attitude of being "indifferent toward everything" becomes a protective skin that prevents him from being coopted by the false present.

In the 1972 photograph *La rivoluzione siamo noi,* which advertised an exhibition in Naples, the star of German anti-pop wore the same expression that he had for a Japanese whiskey ad. This time he borrowed the pose of a revolutionary leader from Giuseppe Pelizza da Volpedo's 1901 painting *Il quarto stato.* However, unlike in the original work, where the background is made up of a crowd of striking workers, in the photograph Beuys is striding alone against an empty background. It remains a melan-

cholic image of lonely revolt. But its pathos rarely appears comic.

From Pathos to Pastry

In 1988, two years after Beuys's death, Elaine Sturtevant had herself photographed in a re-enactment of the photograph *La rivoluzione siamo noi*. Along with the dented hat, she is wearing two other characteristically Beuysian items: a fishing vest and a white shirt. Making her debut appearance as a dandy, she dispensed with the Levi's jeans and the worn-out boots in favor of a pair of creased trousers and high-heeled ankle boots. Despite these differences in the duplication, the reanimation of the dead man is astonishing. The ease with which Sturtevant stepped into the role of the German artist seemed almost uncanny. "Human beings are doubles. Human beings are copies. Human beings are clones. Human beings are dispensable. Human beings are disposable." This was not a mere offhand remark.

Elaine Sturtevant first became known in 1965 with her imitations of works by other artists—mostly male, but occasionally female. Her exhibition at New York's Galerie Bianchini upset the rules about what art should do or should not do by presenting an astonishing move. It departed so far from what was familiar that most people didn't even notice how profoundly Sturtevant had changed the rules of the game. Initially the public reacted with amusement, regarding the forty-year-old artist's work, which they mistook for a form of copying, as a witty Pop Art one-liner. Only a few people became interested in how the former psychology student produced differences through repetitions. One person, however, was

thrilled: "A copy? Elaine Sturtevant? You've got to be kidding," after which the only other thing he could think of saying was: "Wow, Elaine!" Warhol enthusiastically let her have the stencils for his *Flowers* screenprint. Generosity of this kind, which he initially called Commonism, came naturally to him. Everything should belong to everyone and everyone should have fun.

Not everyone saw things this way. When his turn came, Claes Oldenburg felt deeply hurt. In April 1967 Sturtevant replicated Oldenburg's installation *The Store*—an imitation of a shop window—just a few blocks from where the original had stood on Green Street. Up to this point, Sturtevant's art of repetition had been met with indulgent smiles; but now she was confronted by overt hatred. At Oldenburg's instigation, a mob of artists was quickly raised and went in pursuit of this parasite who had dared to feed off original male work. It did not occur to anyone that Sturtevant's supposed vampirism might actually be a contemporary exploration of pastiche.

Pastiche, which today is generally regarded quite negatively, deals with a form particularly beloved of dandies, that of the publicly exhibited inferior imitation. In imitating a model, the pasticheur plays down his own subjective input. Those who accused Sturtevant of stealing intellectual property had clearly never read Marcel Proust's 1919 work *Pastiches et mélanges,* a series of fragments adopting the tone of other writers, such as Balzac or Flaubert. In it, he uses writing styles borrowed from another time to parody what is anachronistic in his present. The term Proust chose for the title of the collection, pastiche, derives from the musical procedure *pasticcio,* a term for a nineteenth-century opera assembled from a variety of different musical models, which in turn comes from the Italian term *pasticco,* meaning pastry. However,

like the concept of the readymade, which is often applied to Sturtevant's work, pastiche only partly describes what she did. The artist never used any industrially produced, prefabricated products. She imitated other people's art from memory and called her objects, which often look as if they've been rather amateurishly put together, *Repetition Pieces.* By describing her own work as form of repetition, she drew an analogy with the vocabulary of psychoanalysis.

Friedrich Wolfram Heubach, who has thought deeply about the psyche of the dandy, points to the affinities between a child's experience of being ignored or neglected by the parental gaze, and the dandy's own self-negation. The urge to repeat the pain of past injuries comes from the human propensity to return to familiar emotions where one strangely feels at home. Sturtevant's procedures aimed at deliberately absenting herself by performatively negating her own subjectivity. In this respect, they resemble the compulsion to repeat described by Sigmund Freud in his 1920 work *Beyond the Pleasure Principle.* Here Freud describes the play behavior of a young child who repeatedly throws a wooden reel away from himself only to draw it back again. The child repeats the loss, and in so doing regains symbolic contact with his parents by means of a substitute object. The playful nature of the game becomes a ritual by which the repetition of disappointment is raised to a higher level. The intimidating experience can be turned into a pleasurable game, since the act of imitation allows one to control whether one is abandoned or not. Sturtevant's repetitions, in which she remained absent as a subject in order to be present as a repetition, were subject to strict rules. She did not follow the rules to invent anything. Everything was already there, and every repetition created a difference.

You're Out

The champions of intellectual property rights had little interest in knowing why she made these repetitions. But one thing they were certain of: this is mine, only I am allowed to do this. They thought they'd created something unique, and Sturtevant's appropriations exposed the exaggeratedly high opinion they had of themselves. She didn't only use her repetitions to challenge this misapprehension, she also mocked those who treated their originality as a kind of brand name, by turning serial plagiarism into her own brand.

She also felt like a threat, since she produced her works in an incredibly short space of time. Sturtevant had a strong sense of what kind of art was likely to last. Those who did not receive the compliment of having their work imitated by her faced the fear of being exposed as irrelevant. And there was something else that disturbed people: Sturtevant's repetitions expressed no discernible opinion about the works she repeated. The imitations left it unclear whether they were caricatures, homages, or critiques. She seemed to process the things she found indifferently. They were assemblages which aimed at reflecting on others' forms of expression, and at subjecting her own expressive will to a strict asceticism. This abstemiousness towards the human desire to display one's own personal excreta provoked overt hatred.

Her self-control was met with repeated acts of aggression. For a long time she fought hard not to give in to the pressure, but in 1974 she decided to withdraw. She abandoned the hostile playing field of art for a red sandy pitch covered in white stripes; as she dashed about it, she reflected that it would be smarter to keep her distance from things for a while. She would use topspin shots to

return the balls into her opponent's box on the other side. She did this with great concentration, and had a power-ful serve. She liked the clear-cut rules of the game, and the white skirt and close-fitting socks that she wore to play it. As she played, she would reflect on why in tennis the serve could be so complicated.

Her withdrawal was not a departure. Although the situation had been exhausting her, Sturtevant only kept away from it for a while. She didn't reject the world as it was; rather she accepted a future that she knew would eventually come. She spent twelve years on the tennis court before what she called the more "retarded" elements of the art world caught up with her. In 1986, when appropri-ation art was enjoying its springtime, Sturtevant returned to the public eye with an exhibition at the New York gal-lery White Columns. While the fashionability of appro-priation art may have contributed to Sturtevant's come-back, its pioneer did not feel obliged to show any undue gratitude. She remained a loner.

The artist John Miller was the only person to point out the similarities between Sturtevant's artistic activity and the strategies of dandyism. In his 1990 essay "The Weather is Here, Wish You Were Beautiful," Miller writes that Sturtevant's playful treatment of personality breathed new life into Oscar Wilde's dictum that it is only the unimaginative who ever invent anything. But more than being unimaginative, in her art Sturtevant embod-ied the dandy spectacle of presenting oneself as an absent personality. Repeating what others did allowed her to give little or nothing away, while remaining at the same time present. Her visible disappearance rejected what twenty-first–century capitalism insistently demands: that we peddle our own subjectivity. Sturtevant's refusal to exhibit herself and present herself as a subject may have

contributed to the recent revival of interest in her art. In the last few years, the artist has fascinated many who no longer want to submit themselves to the command to make their subjectivity productive.

Some call me Mister Ra.
Some call me Mister Re.
You may call me Mister Mystery.
(Ra)

Perhaps more than anyone else, stanley brouwn explored the invisible. From the mid-1960s, he refused to let himself be photographed. And he tried to withdraw from circulation the few pictures of himself that already existed, even buying the remaindered stock of catalogs that still contained his photo. In the post-internet era, it is difficult to imagine being able to withdraw one's own image from public view. Sixty years ago it still seemed possible. In 1972 brouwn went a step further, politely but firmly demanding that in future no images of his artworks be shown. He reduced all biographical information about himself to a few standard paragraphs. He refused to have any monographs written on his work. He left pages in catalogues blank, and not infrequently he left the rooms in his exhibitions empty. brouwn's asceticism towards any public appearance sought to keep maximum control over his own visibility. He treated his physical appearance as an object that he could cause to disappear, allowing his self to retreat behind his art. All of this did not signify a negation, a *Tell Them I Said No* (2016) in the manner of Martin Herbert, which would place brouwn among those who rejected the art world. brouwn's attempts at disappearing were undoubtedly motivated by a skepti-

cism about art's commercialism, but rather than being a rejection of this, they were much more an affirmation of the immaterial world.

The World According to His Own Measure

To lend emphasis to a stance, there are many things it is necessary not to do. In every conversation, brouwn would ask what could be left out. While his omissions allowed his art to come more sharply into focus, he also succeeded in making his body almost completely disappear from the art world's public eye. brouwn was nearly always heading off somewhere as a way of vanishing, and these escape attempts revealed him as a recurrence of the *flâneur*, someone who strolls about the modern city by letting himself be driven by its attractions. brouwn resurrected the dandy's nineteenth-century relatives by asking random passers-by the way and having them draw maps telling him where to go. He would also regularly ask strangers to explain his way home. He would certify these maps showing him how to get to himself with a stamp marked *this way brouwn*. By using this phrase he established a relationship to himself as a third person. The stamp stated: I am not only I, there is also this brouwn, a double who bears my name and follows other people's directions.

The titles of brouwn's works, such as *going through cosmic rays* (1970), give some idea of the wider context in which he saw his movements. The connection between his walks and extra-terrestrial rays drew a parallel with Afro-futurist mythology and the jazz musician Sun Ra, whose first band was called Cosmic Rays. A few years earlier, Ra had sung "I Am an Instrument." brouwn also described his own body as an instrument capable of

determining the space between the rays. The scale used by this measuring instrument was based on the dimensions of his body: the length of his forearm or his stride. He used these units to measure his surroundings. Then he added brouwn step to brouwn step, producing figures that formulated a mathematical order relating him to the scales of the world around him. By turning walking into a mode of thinking, he transposed himself into a form he had sought to be and said, "I have become a distance." At the precise time when accelerating technological changes, such as cheap air travel, were causing bodies to diminish in importance by dramatically relativizing their relationship to distance, he restored a significance to his own by turning it into a distance. Step by step, brouwn turned himself into a contemporary anachronism.

This self-portrait as unit of measurement, the transcription of his body into quantities that can be numerically expressed, such as the 88cm-long brouwn step, implied a parallel order to the existing one. One of the few details about himself that brouwn made public—apart from the dimensions of his body—was his place of birth: Paramaribo, the capital of Suriname, the most fertile of the Dutch plantation colonies. Suriname only became independent in 1975; until then, the occupying power resisted any loss of control over its sources of revenue. brouwn's relationship to the colonial power, in whose country he lived from the late 1950s, is indicated in his work by subtle gestures, such as when he represents himself by means of a blank white page, when he smears a white page with dirt, or sticks a strand of hair to it. brouwn's practice of asking random passers-by on the streets of Amsterdam to show him the way also contains echoes of the traumas of slavery. The stamp *this way brouwn* could be understood as a kind of order. Unlike his ancestors, however, brouwn was asking for these directions. And his requests did not lead to commissions of work, but to walks, which he loved. He actively sought instructions to do what he liked doing.

But doesn't this interpretation of *this way brouwn* as a perverse echo of colonial exploitation actually undermine the issue brouwn wanted to blur? He was invited to make several disembodied appearances at documenta, and exhibited at the Dutch pavilion at the Venice Biennale. Given that brouwn was black, would a career of this kind have been possible for him forty years ago? The question is relevant because little in the art world has changed to this day: white artists talk about form, while non-white

artists, when they're allowed to appear at all, are more or less directly asked to talk about where they come from. brouwn was less concerned with where he came from than with how to get away from where he was. Even the invitation to his exhibition at the Kunsthalle Bern in 1977 ended with the sentence: "The artist will not be present at the official opening of his exhibition." Absent appearances gave him a greater freedom of movement, and combined with his search for a spiritual truth behind the material world. Although this conceptual artist before his time did not ignore material reality, he did embrace the side of it that was not manifest. What his search for a spiritual truth did not make him was another "invisible man," as curators would repeatedly refer to him in reference to Ralph Ellison's 1952 novel. Unlike the fictional character, brouwn used his art to gain a public profile, while the invisible man, traumatized by a barrage of gazes and physical attacks, was forced to retreat to the invisible stage of a cellar.

My secret is that I don't have one
(Darboven)

Hanne Darboven inhaled the smoke from her Reyno
Menthol, taking long, deep drags. The clothes she wore had
been designed according to a strict principle. They were
composed of an ensemble consisting of eighteen parts,
which she had had made for her by K. Frech, a tailor in
Hamburg's Brandstwiete. Four three-piece suits, making
twelve parts altogether, together with six blouses and
pairs of wide braces, which were counted separately. Belts,
like anything else that constrained the body, were out of
the question. That body stood erect in Adidas sneakers,
with their balanced tread. On her wrist she wore not one
but two watches, since one of them might stop. She called
these distinctly masculine suits her *Hannekleidung* (Hanne-
wear), and they were her armor. She wanted to have con-
trol over every peculiar situation. Her Hanseatic upbring-
ing had taught her that human beings should live pas-
sionlessly and untouched by feelings. Action came from
discipline. In this cold world, the uniform was her aid. In
her three-piece suit, she rejected the distinguishing fea-
tures of her gender. Instead of displaying a woman's arts,
she dressed her body as something between the sexes. Why
do things the way they are done? Until the day she died,
she lived with her mother in the family home on a rambling
estate at the city's southern edge. This is also where she
was buried in 2009. Darboven loved animals. She always
had white goats and a canary. She called her first goats
Micky and Wurtzy. The bird was called Piephans. Their
successors were sequentially numbered; even the black
stones surrounding her grave are dedicated to Little Micky,
Wurtzy, Piephans no. 1 + 3, 2 + 5 and Papa Piephans. Every-
thing followed an order; that was also part of her armor.

An American friend called Darboven "Isolator," since she kept herself at a distance. That is not to say that she had no contact with other people. Early in the morning before starting work she would watch the news; then she would spend two hours dealing with international correspondence before driving with her mother to a restaurant at twelve o'clock. In the spring and fall she flew to New York to see the latest trends in art. In the seclusion of her country house, she had daily meetings with the employees of her firm, the bevy of people who worked for her and with whom she surrounded herself in an echo of J.J. Darboven, her father's coffee business. For a while, a fiancé would visit her. The diamond merchant from Antwerp would wait in a nearby inn until evening, when Darboven found time to see him after her day's work. However, she decided against marriage, and embraced a life as a sealed love machine. Instead of reproducing herself in a nuclear family, she lived out her life like a human automaton. However, the female bachelor machine rarely called what she did work. A dandy machine does not work. She also rarely spoke about her art. It was what she did. She did it neither to be creative nor to understand herself. It resulted from a system of cross totals of digits of days, months, and years. "Two is one times two—as far as I'm concerned, all laws operate according to mathematical principles." Alongside columns of figures, sharply snaking lines make up the daily transcript of what had been. The handwriting in these accounts consists of empty black waves, crossed out with perfectly straight lines. "I write, but I don't write anything." Her record of transience was influenced by the lived reality of her father Cäsar Darboven, whose columns carefully recording debit, credit, and balance calculated the movements of untold millions of coffee beans. As a daughter

who kept her distance from the real world, she stripped the figures of any material referents, and neglected the margins. At first sight, Cäsar Darboven appeared to be the greatest source of friction, but this was misleading. Her games of repetition also said that the biological father is just one trauma among many, an excuse for pussyfooting around and whining daddy, daddy, daddy all the time. Instead of wasting her time on that, Darboven preferred to imitate the tone of voice her father used to strike deals, when he would adopt a manner of speaking that combined salesman-like curtness with a note of negligent affluence, occasionally exaggerated with a degree of self-irony.

Along with repeating her father's tone of voice, she liked copying articles from the news magazine *Der Spiegel* or passages from the *Großer Brockhaus* encyclopedia. She wrote only for herself, since it had to be done. But she did it on a stage. She isolated the record of her systemic work in the spaces of art. Her writing expressed time conceived at the moment of its disappearance, a turning away from the past, a moment of change.

In 1989, many people agreed that a breach had occurred in history, and the Berlin Wall fell. From this point on, Darboven began collecting dolls and other toys from the twentieth century. Later her cosmopolitan children's worlds would appear in her exhibitions. These witnesses from another time gained a voice, without lapsing into functional communication. Much like her writing, which was organized according to a strict system, the dolls communicated in their own way. Darboven did not seem to care how people responded to them. She was always ready to hear what people had to say, but never expected to trigger a particular reaction.

As the world behind the Iron Curtain was opening up, another radical rupture took place: Darboven, who was then working on *Kinder dieser Welt* (1990–99)—cabinets of curiosities containing dolls and props—cancelled her subscription to *Der Spiegel*. She justified the decision not on the grounds that it had lost its bearings following the end of the Cold War, but by saying: "I don't read any more, because I've read enough in my life." She turned her back on the past and played with the children. Darboven did not join in the then fashionable talk about the end of history but, with *Kinder dieser Welt,* greeted a new beginning. As a dandy, she remained true not only to her confidence in the futility of everything but also to her asceticism, which, in a letter of May 22, 1966, she'd already described as a deliberate choice: "By limiting one's freedom, one should be able to create a new, unique freedom and world."

Form Plays a Part

My companion was talking excitedly about an artwork in the exhibition. I thought: this thing doesn't care how it looks. It seemed to be happy with itself the way it was. I was struck by this self-satisfaction, but my interlocutor wasn't listening, and stuck to his well-meant demand. It was an important subject, no one could deny that. It's just that I found something domineering about the way this proposition had become a thing that nipped every contradiction in the bud. An armor that sought only the best. And then its content brushed me aside. Whenever I said something to contradict it, I was rejecting the only correct view and, what is more, discriminating against a minority with whom I had failed to empathize. With its grinning

narcissism, the object considered itself above addressing my feelings of guilt. Mentioning this seemed particularly complicated, not to say pointless, since my interlocutor didn't want to hear it anyway. The question of *how* things were said meant nothing to him. It's important to work on this social and political subject, he'd say, while looking at me understandingly, as if I were a child. It may be that some artworks mean something, but in circumstances where everything is readily exchangeable for everything else, where words like "sustainability" can be printed on anything, no one should set too much store by meanings any more.

Choosing art as a means to set the world to rights can barely be distinguished from neoliberalism's efforts over recent decades to link everything to productivity. If there is to be something like art in a society where every activity is transformed into work, then it should at least try to be of some kind of use, either by conducting research and producing "new knowledge," or by staging a critical theater that aims to serve some purpose. If art remained functionless, it could not change anything; it would be, as Price puts it, nothing more than "the result of perverse ways of seeing, odd modes of thinking, strange ways of behaving." And if art aims at causing something to happen, doesn't that mean that everything depends on its language, on *how* something is expressed and thereby opens up a space? Did the dandy fascinate me so much because he was concerned with reflecting on how we speak?

Thank God No One Knows

Lutz Bacher lived in the suburbs of Bochum, where he worked in the Opel car factory. In the evening he drank beer and smoked Camels. Lutz Bacher also smoked Camels. She knew exactly what proportion of truth a rumor needed to contain in order to be believed. If the mix was right, the rumor would spread. To imagine something, you need the invisible. It's not as if no one knew who was behind her work. The person behind it raised the visor, albeit just a crack. She kept her secret so well that the question arose of whether there was actually a body that belonged to this name, or whether it referred to an imaginary artist. In the mid-1970s, Lutz Bacher conducted an interview with that icon of American lunacy, Lee Harvey Oswald; the man who is supposed to have shot John F. Kennedy. The conversation was held inside her head, and with every reply it became less and less clear who was speaking. Was it Bacher? Oswald? Or was Bacher talking to herself as Oswald? Was the split impression that Bacher gave in her interview part of a game, or was Lutz herself a split personality? By turning part of herself into Harvey, Lutz was able to see herself in her own doubleness. "Human beings are double. Human beings are copies. Human beings are clones. Human beings are dispensable. Human beings are disposable." It was Sturtevant who had said this, the same person who had managed to invent the dandy in the body of a woman. Bacher, who called herself Lutz and whose name may actually have been Betty, developed this insight.

In Old High German, Lutz means "renowned warrior." For forty years, the passionate reader of spy novels used this shield to protect herself against speculations on her background, her body, her age, her intentions, and

her opinions. The German name with its mordant ring was an answer to the question: who are you? Then the police would ask: did you kill the person whose body is lying there on the floor? Bacher laughed. She lived in New York and she liked the superficiality of the city, where you can flash a smile that your lips have already forgotten by the time the other person sees it. She offered this smile violent and pornographic images. They leave the gaze isolated. Nothing can help it. Bacher behaved as if she wasn't there. She took the passivity of the ready-made to extremes. Instead of saying, I picked this thing out, she would use the excuse of the kleptomaniac who tells the store detective that the handbag forced her to take it with her.

In so doing, however, Bacher never confined herself to a consistent relationship with herself. Every one of her exhibitions showed a different Bacher. Between the exhibitions, half a decade would sometimes pass in obscurity. It remained unclear whether this was deliberate or the result of a turn her life had taken. One of Bacher's last self-portraits from 2016 bears the title *Zugzwang*. *Zugzwang* is the name given to a situation in chess where the side that has to play gets a disadvantage no matter how it does so, but must move a piece even if it would rather not. *Zugzwang* is a complete set of chess pieces. The pieces are too large for a table and too small for a park. Every piece has sustained some kind of damage, is twisted, discolored, or battered. Have these injuries been caused by the game? Is *Zugzwang* a self-portrait in the shadow of death, that opponent who ultimately checkmates all of us? Before you know it, the search for explanations slips off the smooth figures.

Praising the Surface

Something similar happens in *It's Golden* (2013), an installation that covers the walls with shiny strips. The illusion—glossy, paper-thin material from a box of tricks bought in Chinatown—papers over a naked vacuum. This is where I am. The iridescent film with its wrapping-paper effect and illusion of gold leaf reflects back my blurred silhouette. Does any of this mean anything? More than any other material, gold is a symbol of wealth. Its trick lies in its scarcity, and in the belief in its value which derives from that. *It's Golden* can be read as an image of the reversal that was first made possible by the era of neoliberalism, and the overproduction that accompanied it. On August 15, 1971, a television broadcast of an episode from the Western series *Bonanza* was interrupted for a message from the President of the United States. In the middle of the cozy lives of the Cartwrights on Ponderosa Ranch, that serial world of motherless men which was named after a goldmine, Richard Nixon announced the end of what up until then had been a guaranteed certainty: that thirty-five US dollars could be exchanged for a troy ounce of gold. The closing of the "gold window," the removal of the link between material resources and their abstraction in money value, now made it possible to bring ever greater numbers of dollar bills into circulation, irrespective of whether or not their value was backed up by the gold reserves in Fort Knox. By decoupling money from matter, and by creating the possibility of consuming more and more, the doors were opened up to the environmental catastrophe. The abstraction of decoupled money made the material world appear like the planet seen from a spaceship departing for the moon. From offstage, a voice sang:

"Faust was right, have no regret
Gimme your soul, I'll give you life
And all the things you want to get
So follow me, just follow me"
(Lear/Monn)

Where We Were Eating When the
Third World War Broke Out

It's Golden reminds me of the photo where Lutz Bacher
appears with an inscrutable Mona Lisa smile. Her body
is packed into an enormous dark down jacket, and her
eyes, hidden by gold mirrored sunglasses, seem to whis-
per: I have nothing to say. Like Bacher, there are many
days when I would rather not open my mouth, nor be
seen by anyone else. On these days, I'd like to go to a
restaurant with my sunglasses on, and find a table right
at the back. With my back to the hubbub, I look at the
wall and think: if only the world would leave me alone,
everything would be simpler. But that is only half true.
Even the act of disappearing involves a desire to be seen.
Is that what attracted me to the dandy? At once both
present and absent, he could murmur three words in a
corner and in the end no one would forget him. And
while I was sitting with these thoughts in the fin-de-siècle
charm of Jack's Brasserie, I became aware of how com-
plex the reasons were for one's choice of where to sit.
Almost every restaurant is a stage where the guests are
discreet spectators, running their gazes over one anoth-
er. In Jack's, whose view of Bern's train station gives it
the atmosphere of an exclusive waiting room from anoth-
er time, the seats are adorned with small brass plates
showing the names of those who once sat in them. Not

just anyone, but people like Grace Kelly or local poten-
tates whose names I don't recognize. I like eating in
Amanda Lear's seat the best. It is on one side of the room
by the window. I sit there with my back to the light and
the street, and have an excellent view of the dining room.
However—and especially when the sun is shining—I am
visible only in outline, backlit as in a photograph. As I
make my appearance as a silhouette I think: for Lutz
Bacher, not being there was the key to being effective. She
understood how to beat enemies without engaging them
in combat. Bacher the dandy did not respond to the *zug-
zwang*; she let it come to nothing. Her absence resembled
what in the Buddhist concept of nothingness is known as
kong, and is related to the Taoist insubstantiality of *xu.*
Your heart makes its departure, and you become a name-
less nobody. Then I asked the waiter if the third world
war had started yet. He shrugged his shoulders, as if it
mattered. Then he handed me a menu from December 10,
1939. The list of dishes began with: *caviar à ma façon.*

I Am Empty and I Like It

Truman Capote called him a sphinx without a secret.
Andy Warhol seemed to enjoy his own self-alienation
without a hint of sentimentality. With his aura of inner
emptiness, he became the great model for a future dandy
of the masses. To this day, many people want to become
like Warhol and say: I am empty and *I like it.* Was this a
form of projection onto someone who seemed less vul-
nerable beneath his wig? When he wasn't actually getting
shot, what protected him was the tense surface of his
body. He had transformed it into a membrane that could
register everything. The "recording angel," as his friends

"Vidal Sassoon Natural Control Hairspray for men—
the art of style.

Andy Warhol,
Artist,
New York, N.Y.

called him, registered things without expressing an opinion, and dreamt of processing the world like a machine. "Machines have fewer problems, I would like to be a machine." All the poison of the world would run off him like drops off a raincoat.

Every morning he would automatically check to see if the gossip columns had spelled his name properly. It wasn't that he considered the incorrect spelling of his name a kind of injury; on the contrary, he experienced himself as a mutilated object: "I'm so cut up that I look like a Dior dress. It's pretty awful to see yourself in the mirror with it. But somehow the scars also look good." As a way of showing his wounds, he produced the film *Flesh for Frankenstein* (1973), in which he himself appeared as a body without a head. It was unlike any avant-garde film seen before. Warhol had hired the director Paul Morrissey, who mixed horror with soft porn to produce a camp B-movie, and it was shown in cinema-scope like a major feature film. Although the film can be dismissed as self-important, that would also be to miss the political dimension of its pretentiousness. For a social climber like Warhol, pretentiousness offered a means of appropriating the rules of a social game from which his background excluded him. One of the clever provocations in his *Auto-Blow-Ups* was to take whatever society held against him, exaggerate it, and turn it into a style. It was in Europe that the gay kid from a working-class family had his first success. When he arrived in Paris in 1970, Warhol was still regarded as a self-publicist in the United States, and treated with skepticism. But to the Parisians, his style, from his 501s to his wig, his open admiration for the surface of things, and his entourage of scruffy young people made him seem incredibly chic. Within a few days, he had received the ultimate accolade: Baroness

Marie-Hélène de Rothschild invited him to dinner. It was a somewhat tense tête-à-tête, which he had to wash down with large quantities of Coca-Cola.

The next morning, he eagerly started work on his actual project. He wanted to shoot a film in the City of Love. The script didn't need to invent much: two New York hippie girls come to Paris, paint their nipples with makeup and become objects of desire. Karl, played by Karl Lagerfeld, hires them as models. Warhol, who immediately recognized the inferiority complexes of this scion of a tinned milk dynasty from provincial North Germany, gave him the role of the clothes-designing aristocrat he so longed to be. For his part, Lagerfeld, a talented grifter, immediately recognized that Warhol embodied an entirely different way of engaging with the world and represented the future; the master of evasion and maceration appeared as an empty subjectivity, whose negative content affirmed itself. This was an entirely new kind of short circuit between presence and absence, which caused every attempt to describe it to melt like cheese on a cheeseburger. Much as the fashion designer would have liked to have become like this sickly-looking beanstalk from Pittsburgh, he found the sense of inner emptiness difficult to bear; instead, he absorbed what he could of his model like a dry sponge. He offered Warhol his flat in the Place Saint-Sulpice as a location for the film. Interior decoration wasn't only what he was best at; it was also where he came closest to the dandy, namely in the love of surface. But for him, no enthusiasm was without an ulterior motive. He himself was no dandy, and could never simply have fun. Amid the Art Deco furniture, there emerged a cacophony of brash and tawdry hullabaloo, chemical pleasures, and Parisian kitsch. *L'Amour* (1971) may have remained unsatisfying as a cinematic experi-

ence, but it is less about what is visible on screen and more about the relationships behind the images. Though the film is very rarely shown, it reveals the influence that Warhol had on Lagerfeld. The fashion designer learned from the American dandy how to capture the public's attention at one's first appearance. Without Warhol, Lagerfeld would probably never have taken his own style of "aftercamp"—that sublimely bad luxury trash taste which Chanel developed under his direction—to the same extreme degree. Lagerfeld invented a bizarre appendix to something that would once have been considered a gesture of negation and escapism. Lagerfeld's aftercamp for Chanel congealed into a surface of the commodity world, which to this day remains enormously popular in places like Dubai, Shanghai, and Moscow as an idea of the West. Warhol's influence on Lagerfeld becomes so obvious in the film that the latter repeatedly distanced himself from the shooting of *L'Amour,* which had been his initiation rite. However, Warhol also anticipated something far more momentous in Lagerfeld's life: he would be the first to meet his great love.

The Handsome Flight Attendant

After he'd finished shooting *L'Amour,* Warhol flew back to New York with Air France. He liked the airline's bold modernism, and he enjoyed meeting French people, since they could talk as much as they liked and he didn't have to understand them. This time he was entertained by a young man who said: I am here for you now. However, the situation did not remain innocuous for long. The steward had taken mandrax, a drug that induces feelings of indestructability, and during the flight he came to be-

lieve he was Ludwig II of Bavaria. Warhol was amused, but then his inner alarm bell started ringing: this person is too dangerous for you. He decided: "my memory is a tape recorder with a single button: erase." And he forgot Jacques de Bascher.

Other people remembered him very well. Dressed like a character from a novel by Marcel Proust, he looked as if he had emerged from another time. Bascher not infrequently liked to aggrandize his last name. While other children made Napoleonic epaulettes for themselves, de Bascher, even as a small child, dreamt of an aristocratic upbringing. He cursed his undistinguished family, especially his servile great-grandfather, a peasant by the name of Bascher, who had been ennobled by the French emperor in recognition of his loyal defense of the crown. Instead of ascending like angels, they had found advancement by abasing themselves, and the memory of this mortified Jacques. De Bascher did not merely dream about social advancement. The outrageous fact was that for a while he had to work. Like everything, he transformed this indignity into an adventure. First he got a job as a sailor in the navy. He would pick his nose and mince about the deck of the *L'Orage* in his striped shirt like a Gaultier model *avant la lettre*. In Tahiti, some exuberant group showering caused him to wind up in jail. He found that he liked it, reflecting upon the words of the concubine author Jean Genet: "I mix things up, I throw them into confusion, and you think it's just childish games. It is just childish games. All prisoners are children, and it is only children who are devious, crooked, lucid and crazed." Everything in Jacques's head was literature. He did not return to his ship. The next scene would be Paris. He would hang out at the Café de Flore in a casually knotted silk scarf, with a copy of Montesquieu on the table in

front of him. Rather unusually, he wasn't reading. He needed to rest. He'd been modelling that morning for David Hockney.

Getting access to the best circles was child's play for Jacques. He was helped not only by his handsome physical appearance but also by his penchant for sadistic relationships, in which the other always played the subordinate role. He seduced Yves Saint Laurent into climbing into a dark cupboard, whose doors he then locked. It was an opportunity to live out a dream, from which Saint Laurent emerged hours later in an apparent daze of happiness. While Jacques's relationship with YSL did not go beyond an affair, he and Karl were a couple. Their love lasted eighteen years, despite it being, as Lagerfeld would repeatedly emphasize, a platonic relationship; had it not been, he'd add, he would almost certainly be dead. For Lagerfeld, who didn't drink, didn't smoke, didn't take any drugs, and didn't like sex, de Bascher was an alien from the planet of popping corks, and the heart and soul of the parties by which he tried to outdo his competitors. What fascinated the designer about his great love was his ambiguity: "A devil with Garbo's face. He did not dress like anyone else. He was worlds ahead of all of us. He was also impossible and abominable. He was perfect." Jacques, the brilliant pioneer of styles, had no ideas, wasn't able to design or do anything practical. Work was for the hapless; in an age without a future, he possessed the attraction of youth. Fashion turned to the dandy, who knew everything before everyone else, as if he were the oracle at Delphi.

The House of Murmuring Walls

It was two o'clock in the morning. After looking through the spyhole of my apartment door, I couldn't sleep. Two drug addicts were sitting in the dilapidated stairwell of my block and tapping together little white rocks. A flame thrower, which looked as if it was for making crème brûlée, made me worry they weren't just going to use it to light the crack but would also set the building on fire. When they finally left, I felt horribly cheerful. The air in the apartment was still, and the moonlight was flooding through the window, casting long streaks across the floor. To get the shock out of my muscles, I went downstairs and got on my bike. The clock showed it had just gone four: the hour of spleen and mourning. A moment later, I was cycling down the Königstrasse, crossing the Reeperbahn, and from there heading straight on into the world of white houses. I cycled for an hour, and only stopped when I reached Wilmans Park in Blankenese. The street with a grand name turned out to be a steep cul de sac, and I lent my bike against a wall at one end of it. The three-arched gateway seemed somewhat overblown. On one side of it, a flight of crumbling steps led down to a small, dense wood. Once I'd got down, I found that the property was concealed by a low wall. I jumped over it. After a tense moment, I was able to establish that its grounds weren't alarmed. The last owners had abandoned the building long before. The house was on the market, but it seemed they couldn't sell it. The problem was the heating system, which needed replacing. I crept down the gravel path and around the ivy-covered building, which looked even more sinister at night than during the day. In his monologues, Lagerfeld had referred to this as the "German house." It had been built in 1923, in a pastiche of the ancient Roman

LAGERFELD
JΛKO

style, by a marine insurer seeking to secure himself against the hyperinflation. The builder only stayed in the building for three years. After that, it was inhabited by a sea captain, who enlarged the house by one floor.

For Lagerfeld, who bought the property in 1991, its dark form evoked past times—both those of his childhood and memories of his years with Jacques de Bascher. Lagerfeld christened the house the Villa Jako, since that was the better story. For him, the memorial was a place where he could imagine himself being; he barely spent any time actually living in this vessel of the past. He concentrated on decorating the house. Once the interior had exhausted his interest, he sold it. Obviously this was not about the money; he left because he could hear the voices of his parents murmuring from the walls.

The new owners did not stay long either; they moved out again after a sudden divorce. The wife groaned: "It was a shock. The house was a nightmare, the only redeeming feature was the garden." From there, I climbed the imposing steps to the terrace of the empty building. As I looked about, gazing on the garden illuminated by the full moon, I felt I had walked into a metaphysical painting.

The Greatest Idler of All

De Bascher was capable of exuding a dazzling charm one moment and an extreme nastiness the next. These volatile shifts of mood were his key to the world. When he turned it, everyone swooned. Then he'd become moody again and didn't seem to care about anything. He had a particular indifference to mundane matters. Paying rent, electricity, or gas was something other people did. Money didn't interest Jacques; that's why he spent it. And

Lagerfeld took care of everything for a very good reason: he wanted to see his great love living the dream of dandyism that was inaccessible to him. Like *Rameau's Nephew* (*Le Neveu de Rameau*, 1805), Denis Diderot's sworn enemy of the Enlightenment, de Bascher was "both a man of remarkable taste and an egregious crook," who, as Giorgio Agamben puts it in his 1970 work *The Man Without Content* (*L'uomo senza contenuto*), seemed to care little for the difference between good and evil. This moral vacuum not only helped him gain aesthetic distinction, it also drew others to him. Jacques had only to breathe and people flocked to him. The black hole had a sure sense of the style that he held in contempt: essentially that of his own time. If he got up at midday, his taste was already three steps ahead of him. In the early 1970s, when industrial modernity was running into a brick wall, he watched the head-on economic collision sporting a traditional Bavarian loden suit. He owned a dozen copies of the coat worn by Ludwig II's gamekeepers. In the year of the oil price shock, what could be more stylish than this return to the future? Naked beneath his woodsman's uniform, he would dream of the orgies that the Bavarian king was said to have held in the hunting lodge by Schloss Linderhof. The best thing about these erotic fantasies was that the model for them was itself a copy of a fictional object. The Swan King had constructed a copy of Hunding's Hut from Act I of Richard Wagner's opera *The Valkyries* (1870), and by doing so introduced an imitation of a theatrical scenery into an actual landscape—a celebration of the artificial over the authentic. Ninety years after the *fin de siècle*, de Bascher was exalting the general sense of decline: "the term 'decadence' comes from the Latin *cadere,* to fall. To be decadent means to fall into beauty. It is very slow and beautiful. It can be a

kind of suicide in beauty." Everything was going to col-
lapse, and look incredibly good as it did so.

If we describe someone as being decadent, it is gen-
erally meant negatively. The derogatory term aims to
defend a past which starts to fall apart as things collapse.
When people feel under threat, they tend to become
judgemental about how others live. However, decadence
can also be thought of as a form of future-oriented
behavior, serving to hasten the collapse of the crumbling
order. Not only does it subvert the worn-out morality of
a dying era, it seduces others into doing the same. There
is an old Arabian story about the subversive power of
decadence: in it, a group of worthies attempt to reform a
notorious gambler by having him locked up in a house
with ten righteous men. When the door is opened a
month later, they find the house has become a gambling
den, where, immersed in squalor, eleven depraved souls
are playing dice.

The Dedicated Slacker and His Party Content

Periods of decline are usually more fun than periods in
which new orders are being consolidated. In the declin-
ing years of industrial capitalism, de Bascher devised
parties as if he were adding a risqué chapter to a great
novel. The living images were inspired by his intermina-
ble travels in literature. The *White Dinner,* held on the
north bank of Lake Geneva in 1976, was an inversion, in
the manner of a photographic negative, of the black din-
ner from Huysmans's *Against Nature.* Its high point was
the dessert, a powdery table decoration which guests in-
gested through their noses. There was so much of the
stimulant that the fire brigade, which had also been invit-

ed, got coked up to their eyeballs, cranked their ladders towards the sky and climbed up them. Then the two hosts cruised off in their chocolate brown Rolls Royce. Jacques remarked to Karl that healthy people just take longer to die. For their next event, the couple sent out invitations to a *moratoire noire*. Organized to accompany a show by Chloé, it too evoked Huysmans, and was to become a night that would change Paris. The evening had a motto—"temporary non-payment of debt"—and was initially planned as a tribute to Karl; however, it was changed at short notice into a memorial event for Andreas Baader. A few days earlier, the terrorist had been found shot dead in his cell in Stuttgart's high-security Stammheim prison; his wound consisted of a contrived shot through the neck, of the kind used by the SS to kill their victims. De Bascher did not regard himself as Baader's comrade, rather he saw in him a reincarnation of his literary idol, the child murderer Gilles de Rais. A person who sets himself above morality and presumes to play God. For the party held on October 24, 1977, the reigning king of the dandies had rented La Main Bleue. The club, which was largely frequented by sapeurs, was in Montreuil at the end of metro line 9, a long way from the center.[2]

Although it had only just opened, Paloma Picasso and Rainer Werner Fassbinder were among its regular guests. The basement beneath a shopping center had been transformed into a black hole. The *moratoire's* dress code also stipulated black. Many of the almost four thousand guests tried to look as if they had come out of a Tom of Finland drawing. Everyone shrieked when a floodlight suddenly lit up the dark space, and the whole party watched a starkly illuminated fist being thrust up someone's behind. After this night, Paris clubs that didn't have a dark room were considered passé. Was this trans-

gressive event an act of sabotage of the kind associated with the *démoralisateur,* Benjamin's "destructive character," who aids the collapse of a crumbling society?

Enlightenment's Dark Cellars

Jacques lit a Lucky Strike. Everything he did gave the impression that he had just gone on holiday. He even invented the fashion film, an entirely new genre, as effortlessly as if he had been walking along a beach. *Histoire d'eau* (1977), his only film, originated as an atmospheric accompanying piece to Lagerfeld's first prêt-à-porter collection for Fendi, and took as its model *Histoire d'O,* the scandalous sado-masochistic novel from 1954. The main character tells her parents that she's taking a cure in Baden Baden, when in reality she's idling away her time in Italy, wandering through the streets of Rome. At the high point of her dérive, the jet-set situationist descends a flight of steps naked, half hidden by a fur coat, only to drop Fendi's youngest model at the bottom. The film opened up the opportunity of a career for de Bascher, but he wasn't interested in any kind of work apart from dedicated idleness. Ultimately he was still just playing: show me your penis and I'll tell you who you are.

In the early 1980s, electronic music reached Parisian

2 In contrast to the European dandy, who cultivated a discreet style in his manner of dress, the sapeurs went to great lengths to make themselves visible. Leaving home meant getting on a catwalk. The term *Sape* comes from an abbreviation for *Société des ambianceurs et des personnes elégantes,* and also sounds similar to the word *s'habiller,* to get dressed. In African cities, wearing a suit was primarily understood as a form of cosmopolitan resistance to *authenticité,* a movement which called for an identitarian, proto-African look. The sapeurs rejected *négritude,* wanting, as Fanon put it, to "shake off the dust from that lamentable livery built up over centuries of in-

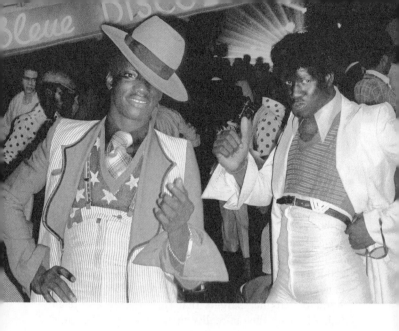

nightlife. The cool rhythms of the machine inspired a feeling of being ecstatically alive. The subterranean vault darkened as de Bascher descended a couple more steps into it. He was still descending when the HIV virus hit, dividing time into a before and an after. He walked into the catastrophe with his eyes wide open. It was only when Michel Foucault died, another regular at Paris's S&M bar Le Keller, that Jacques had himself tested. He was positive. The two of them had not only met at Le Keller, they'd also danced at the Mineshaft club in New York. Their platonic friendship had a special affinity with the figure of the dandy. In his 1984 essay "What is Enlightenment?" ("Qu'est-ce que les lumières?"), Foucault invoked a modern reincarnation of the ascetic, and related him to the conditions that must obtain for him to emerge from a state of immaturity. Those who reject the eclipse of consciousness cease to conform. Enlightened individuals no longer leave decision-making to institutions. For Foucault, enlightened behavior involves empowerment but not self-realization. Rather, it is a system of rules by which the self can withdraw, allowing the developing dandy to interact with his environment. They start to "take themselves as object of a complex and difficult elaboration," and to practice what Charles Baudelaire called *dandysme*. "Modern man, for Baudelaire, is not the man who goes off to discover himself, his secrets and his hidden truth;

comprehension." In the sapeurs' formulation, clothing is a kind of passport, an identity issued by the ruling powers. Jackets are turned inside out, so everyone can see the makers' brand names. Bacongo, Brazzaville, and Kinshasa are not places where understatement gets you terribly far, but they may have invented logomania. Since their fashion excesses both evoke and undermine an idea of the dandy, the question arises as to what extent the sapeurs' performances are parodic. Or are their exaggeratedly visible poses both a self-negation and a subversion of the injunction to be invisible?

he is the man who tries to invent himself." While Baudelaire still described the self-creating dandy as an important model for art, Foucault saw in the dandy's self-reflective process of formation a precondition for political action. Efforts to shape his personality and manage its construction are part of the process of forming a modern consciousness of political action, the patient labor along the border that "gives form to our impatience for liberty." It is only by the formation of what we call the "I" that a personality can be developed that is capable of entering into dialog with others, thinking politically and negotiating problems. The process involves what Foucault calls the "arts of existence [...] by which men not only set themselves rules for conduct, but also seek to transform themselves, to change themselves in their singular being, and to make their life into an *oeuvre* that carries certain aesthetic values and meets certain stylistic criteria."

Foucault's reflections on self-care have often been interpreted as if they were primarily about the individual person. This association with food supplements and bodybuilding has repeatedly led to Foucault being reinterpreted as offering a philosophical justification for self-directed mindfulness and self-optimization. And yet Foucault was concerned not with privatized forms of care, but with those that could become political by relating self-control to the state of being controlled. Unlike self-care, the rules a dandy imposed upon himself did not aim at self-preservation. What he sought was an ecstatic state in which the self could be extravagantly squandered. In the stagnant conditions of a post-political present, this way of thinking about the dandy as the process of self-formation into a political subject again seems to offer a way out. Neoliberalism succeeded in normalizing

a situation where collective problems are not addressed. In a society that increasingly privatizes everything, the collective management of problems is being abandoned. The current fatalism about ever being able to become any kind of political subject extends from visions of an omnipresent capitalism that preclude any alternatives, to fantasies of a world controlled by sinister forces. In this general sense of powerlessness, the sovereignty of the self is driven back into the private realm. Instead of politicizing themselves and raising the issue of the collective good, isolated individuals discipline themselves in order to function better. A counter-challenge to this could consist in rediscovering self-care in the spirit of a Foucauldian art of living as a practice shorn of any association with self-optimization, as belonging to the realm of the political and as a form of behavior oriented toward the community. In so doing, it might be possible to inspire a political dandyism.

On Monday the World Comes to an End

The great crisis that set the stage for dandies like Jacques de Bascher in the 1970s had already begun at the end of the preceding decade. A growing dissatisfaction among those who realized they did not want to work at all led to a slowdown in production as workers withheld their labor, and to riots in Detroit's auto industry.

Not long afterwards, an ominous sign appeared: on March 2, 1972, at a symposium in the Swiss town of St Gallen, an institute called the Club of Rome presented a study entitled *The Limits to Growth*. This vision of an economic dead end almost immediately became a bestseller, with worldwide sales of twelve million copies. The two-hundred-page diagnosis was based on calculations made at the Massachusetts Institute for Technology in Cambridge: computers used data from all areas of life to produce forecasts for the future. The results found that industrialized economies were only heading in one direction. One way or another, continuous growth was going to run the system into a wall. If human beings didn't drastically change their behavior, the future would be characterized by floods, famines, epidemics, and the exhaustion of natural resources. Doubts about the idea of industrial growth were exacerbated by the United States' military defeat in Vietnam and the oil price shock.

The scent of apocalypse hung in the air. The sense of an unfolding catastrophe led to a crisis in the term's original meaning: that of making a decision in a moment of danger. What the situation called for was a radical asceticism and self-restraint, as a way of leaving behind the capitalist principle of growth. But the new neoliberal actors who had entered the scene pursued the precise opposite: not only were they going to carry on as before, they were

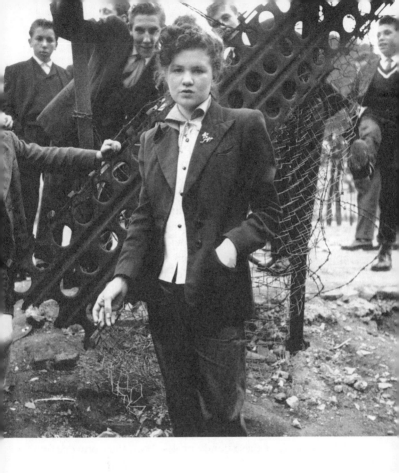

going to accelerate industrial overproduction. There was resistance from those who took the warnings seriously. One group adopted the slogan *no future.* From their marginal position in society, they rejected the old idea of progress and came up with a surprising new twist in dandy asceticism. The prelude to punk included, alongside mavericks like de Bascher, groups such as the Edwardians, who later became known as Teddies. The name chosen for itself by this particular proletarian youth movement, which had been founded in England in the late 1950s, was based on the distinguishing characteristic of the "Edwardian," a straight-cut coat with wide lapels and striking appliqués. The cut derived from Edward VII's reign at the beginning of the twentieth century. Teddies did not just reject innovation in how they dressed, they also saw themselves as opposing anemic middle-class tastes with a proletarian fortitude. Style appeared to be a way of compensating for political losses, in a period when the welfare state was seriously undermining the social cohesion of the working class.

In 1972, in the aftermath of the shock from *The Limits to Growth,* and at a time when barely anyone knew what to make of the contemporary anachronisms that were the Teddies, a young couple in London fell in love with the look of these dandy proles. With their provoca-

3 The oversized zoot suit, which first emerged in the United States, stood for an aesthetic of aggrandizement. A zoot was a signal that you associated yourself with those who were not considered respectable. The gigantic suit with its lavish quantities of cloth could express a scruffy or a casual grotesque, depending on one's taste. A zoot could not be worn to the office. But for most zoot wearers, workplaces were simply a reality of life that was beyond their reach. The zoot undermined the efficiency that suits were supposed to embody as the office uniform of a pragmatic and streamlined modernity. Anyone choosing to disappear into its vast expanse joined the ranks of those who would never have any chance of getting a normal job. Part of

tive, sensuous energy, the Teddies embodied their ideal: "be childish, be irresponsible, be everything this society hates." As a means of promoting this flirtation with anti-working class prejudice, Vivienne Westwood and Malcolm McLaren opened the boutique Let it Rock at 430 King's Road in London.

As well as Edwardians, there were zoot suits hanging on the racks, oversized suits whose rejection of moderation had once made them symbols of self-empowerment.[3] They promoted the petty-criminal chic that had led to the zoot suit riots of 1943, adding elements from British post-war Savile Row fashion. To them, it was quite simple: "Life is about plagiarising. If you don't start noticing and nicking things because they inspire you, then you stay stupid." Westwood and McLaren stole like magpies and called it détournement. A different kind of dandy emerged from the grave, and had this answer to the crisis: I like being unemployed, poor, bored and depressed. This grand rejection of the misery of the wrong life opened up the possibility of using idleness to take one's life into one's own hands. In a pre-apocalyptic reality, an attitude that had largely been a luxury of the haves became for a while a dandyism of the poor. For the time being, the world was not coming to an end.

this fashion, which had first emerged in the mid-1930s in clubs in Harlem such as Sammy's Follies or the Savoy Ballroom, involved switching between visibility and invisibility, inclusion and exclusion. The trend had been invented by African American and Mexican youth, who would buy or make suits for themselves several sizes too large. The gigantic men's suits were popularized by the film *Stormy Weather* (1943); in them, the body disappeared, while at the same time the wearer became more conspicuous, since his appearance claimed space and visibility. This balancing act was in turn taken up by the oversized styles of Hip Hop. The expansive zoot suit assures its wearer a self-confident entrance. During World War II, those who made

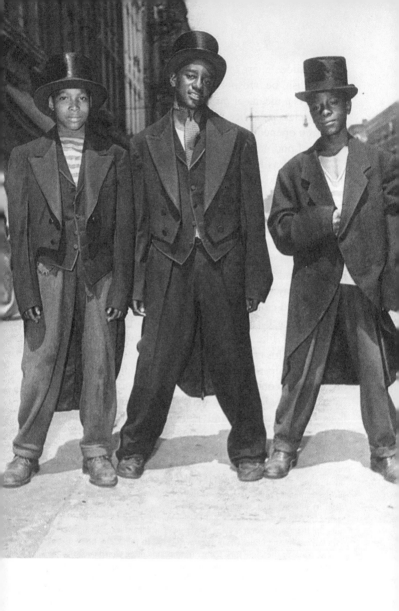

The elegantly dressed woman appears strong and utterly determined to survive. The viewers learn hardly anything about her story, only that she is abandoning a past in which she had everything. The nameless woman buys a flight *aller jamais retour:* one way, no return. She travels to a place where she doesn't know anyone. There she seeks to live out a passion to which she can unreservedly abandon herself. She lands on a Pan Am flight in a wintry Berlin. Instead of her passport, she shows the border official a tourist guide to Berlin. Her hope is to turn the city into her passion's great journey of discovery. In the airport she empties her first glass, and a second one soon follows. A voice over the loudspeaker says, "reality please." She laughs: this is the social contract she intends to break; she scratches out her reflection, only to pour alcohol over it. Then she drinks some more glasses of schnapps, as if she wanted to wash down her own misgivings with them.

Drunk, she staggers around the streets while still managing to look good. She is no housewife drinking in secret; she does not clean houses or live on the street; she does nothing but drink, with Prussian discipline. That, and change from one costume into another. The woman is played by Tabea Blumenschein in Ulrike Ottinger's 1979 experimental feature film *Ticket of No Return* (*Bildnis einer Trinkerin*), and her radiant clothes lift her out of

the zoot part of their look were non-white, mostly poor, and occasionally criminal; they were those with the temerity to use their conspicuous suits to gain special attention, and they did so as an act of pure provocation. In Los Angeles in 1943, U.S. Marines attacked Mexicans wearing zoot suits, among them many women, the *pachucas.* They were accused of wasting rationed woollen cloth in wartime. Resistance to the racist attacks escalated into the zoot suit riots, which spread to Detroit and Harlem. The conflicts led to the wearing of zoots being banned and subject to fines.

the gray reality of West Berlin, which, in the guise of "social question" and "accurate statistics," demeans life by reducing it to bureaucratic procedures. Above all, the drinker, a punk in beautiful clothes, remains aloof and admits only a select company into her presence. At these meetings hardly anything is said, though quite often songs are sung. The action is held together by a magical clinking of glasses, by the sound of pouring drinks, by stiletto heels, by echoing rooms or the clattering of chips in a casino. As Marguerite Duras put it, alcohol "lends resonance to loneliness, and ends up making you prefer it to everything else. Drinking isn't necessarily the same as wanting to die. But you can't drink without thinking you're killing yourself. Living with alcohol is living within death close at hand. What stops you killing yourself when you're intoxicated out of your mind is the thought that once you're dead you won't be able to drink any more."

In the nineteenth century, people were constantly debating the question of which culture had produced dandyism. The answers they came up with tended to involve alcohol. Proponents of the idea that London had been the cradle of dandyism argued that the English-man's phlegmatic disposition meant that the dandy must have a cold-blooded English origin: he drinks in order to escape his own lethargy. The French, by contrast, were too hot-blooded to really be dandies. They drank to cool their inner heat and go on talking. The figure of the dandy had a deep influence on French literature, while in England it gave rise to a style of life. Dandies were renowned for their high tolerance for alcohol. This is somewhat surprising, since alcohol reduces one's self-control, a thing of central importance to most dandies. That they still drink despite this may have to do with their melancholy attitude towards life.

When *Ticket of No Return* appeared in the cinemas, the world was reeling in anticipation of catastrophe. It was the threat that a nuclear war could break out, and nuclear reactors would explode. Many of those who believed they were living in the end times just wanted to dance and drink until it all went up.

At the film's premiere in Berlin in 1978, Blumenschein was mobbed. She herself was particularly attracted to a woman writer thirty-two years her senior. A few nights later, the unlikely couple went on a bar crawl, staggering from the Jodelkeller to the Trinkteufel, Kreuzberg hangouts where some of the scenes from *Ticket of No Return* had been shot. During the day they visited the crocodile enclosure in the Berlin zoo, which had also been a location in the film. Patricia Highsmith would later incorporate these excursions into her 1980 book *The Boy Who Followed Ripley*.

The writer was fascinated by the young woman's mercurial nature, her hunger to transform herself. The latter recalled later: "She'd never known anyone who disguised themselves or was always wearing something different, as I did. It thrilled her, in her letters she was constantly asking what I had on at the moment." For Highsmith, Blumenschein's transformations were like a mirror image in which she recognized Ripley, that literary being through whom, when she wrote, she lived out the aspects of herself she'd suppressed. Her association of her imaginary alter ego with Blumenschein's body was clear from the presents she gave her: a flick knife, a watch without numerals, an extravagant mirror or a striped shirt. She bought two of each of these objects and kept one for herself. The presents to Blumenschein were fetishes which Highsmith used to conjure up Ripley's own double out of her typewriter.

I and Other People's Money

Highsmith claimed that no other book came to her as easily as the first volume of the series *The Talented Mr Ripley* (1954). She wrote the first draft in six weeks and it often seemed to her "as if Ripley had written it and I just operated the typewriter." Her literary alter ego became famous a few years later when the novel was adapted as the film *Plein Soleil* (1960) with Alain Delon. Highsmith liked the money that came with this, but what drove her to keep writing was something else. "The *main reason* why I write is pretty clear to me. My life is always too boring." In Ripley, Highsmith had also invented a substitute for her rage. "I represent the unambiguous triumph of evil over good and I'm proud of it." In the figure of the serial killer she projected her longing for amorality and self-obliteration. Soon she was even signing letters "Pat H. alias Ripley."

The imaginary person through which she lived out her desires routinely lied, assumed the identities of others and stole their lives. To do this, Ripley had to kill not just the people who originally bore these identities, but also the person that he had been. His self-extinction begins when he murders the wealthy painter of mediocre paintings Dickie Greenleaf, gaining possession of his inheritance by means of a falsified will. Ripley says of his victim: "He has his money and I have other people's money," and the act gives him access to the good life and the possibility of no longer being himself. From now on, Thomas Ripley calls himself Tom, and imitates the style of the dead bon vivant. He hates the thought of returning to his old identity, the life of the penniless outsider. But assimilating himself to the lives of his victims offers no release. Ripley keeps looking for who he could be, and always wants to be someone else. His hunger is never satisfied.

Although the author presents him as having abandoned his old identity, he never fits the bodies he has assumed. His carefully-studied appearances remain an act. The stigmas inflicted by class society always catch up with him again. His body remains marked.

Presenting an extreme instance of abandoning one's social origins, this coming of age novel is about an invented person who is constantly on the run. Highsmith, an unwanted child, tried to escape her own trauma by inventing this dandy, thereby repeating the shock that she shouldn't really exist at all. In an effort to abort her, her mother had drunk turpentine while pregnant. Having come into the world despite this, Highsmith tried in the aftermath to disappear into the text. All her previous actual attempts at escape had failed. She transformed her failed career as a painter into literature. Instead of painting herself, she wrote stories about painters. Ripley in turn developed into a parodic self-destruction of the painter she'd once wanted to become. He appropriates the life of a dead painter by faking his suicide and allowing the dead man to live on as a fiction. He employs a forger to produce the high-profile paintings by the same Derwatt whom his collectors still believe to be alive. As long as it only involves a performance, this play with subjectivities goes well for a while; but then doubts emerge about the authenticity of the forgeries. In London Ripley has to appear before journalists as the dead painter's double. He claims that, to present its subject convincingly, "I have no periods. Picasso has periods. That's why you can't put your finger on Picasso—if anybody wants to. It's impossible to say 'I like Picasso,' because no one period comes to mind. Picasso plays. That's all right. But by doing this he destroys what might be a genuine—a genuine and integrated personality. What is Picasso's

personality?" His performance as a phoney painter of forged paintings, which Highsmith uses to involve her hero in an art historical joke, is successful.

Ripley became a figure readers could identify with, and in so doing absolve themselves. He is so much larger than life that he relieves readers of any sense of self-reproach for harboring malign fantasies. He also embodies the role model of the coming generation of synthesized dandies. As such, he anticipated something of the artistic practice whereby the artist's name becomes a container for a variety of other artists and assistants.

The Cologne Complex (Prelude)

In 1978 a young man in a hat rode a scooter down Adalbertstrasse in Berlin's Kreuzberg district, heading toward the Berlin Wall. The people passing him on the pavement thought he was a worker having a bit of fun on his evening off. In the bars the tall young man danced so beautifully that even Tabea Blumenschein was intrigued, not someone who usually found men attractive. Her dancing partner, who introduced himself as Martin Kippenberger, would occasionally let hundred mark notes fall out of his pocket. This was his inheritance from his mother, which he was trying to get rid of as quickly as possible. He spent money left and right, and among the many preposterous things he bought was a share in the Kreuzberg performance space SO36. However, his idea of becoming a bar owner appeared to be little more than a half-hearted bet on going completely broke. As it happened, he put up the price of beer, which didn't go down well. A group of punks beat him up. While he was still in hospital, he asked the photographer Jutta Henglein to immortalize his battered face. He also staged *Dialog mit der Jugend* (Dialog with Youth), part of the campaign of self-mystification that he had already embarked upon.

Shortly after getting beaten up, Kippenberger left Berlin for Italy, where he painted a series of gray pictures. In Florence he felt a strong desire to become an actor. His resemblance to the Austrian actor Helmut Berger seemed to him to be reason enough. The previous year he'd already played a policeman with an Alsatian in Gisela Stelly's television play *Liebe und Abenteuer* (Love and Adventure, 1978). Now he was getting minor parts in films like Christel Buschmann's *Gibbi Westgermany* (1980) and Ulrike Ottinger's *Ticket of No Return* (1978). He dreamt

of playing the part of Ulrich from Robert Musil's 1930 novel *The Man Without Qualities*. He was even offered the part, but the film was never made. After other scripts failed to materialize, he travelled to Paris. Now he wanted to become a writer, but abandoned the idea after just a few weeks. Had he realized that he was not so much a writer as a character from a novel? He came up with a title for the painter he wanted to become: *Durch die Pubertät zum Erfolg* (Through Puberty to Success). It seemed like another attempt at presenting a life that could be read like a story. However, the constant stream of anecdotes was slowly running dry, and he'd almost gone through what remained of his inheritance. He was faced with the humiliation of having to earn a living. Painting seemed to offer a soft option, though he had his doubts about that as well. "Painting takes too long, talking's better, talking's easy."

Painting was also coming into fashion. Kippenberger, who always had one eye on the next opportunity, wanted to exploit the prevailing energies without having to swim in the main current. To pull off this balancing act, he decided not to paint anything himself; instead, he turned to Götz Valien and asked him: *"Lieber Maler, male mir"* ("Dear Painter, Paint for Me"). Valien was an employee at the Werner advertising agency which produced large-format cinema posters, and in 1981 he accepted a commission from Kippenberger to blow up several of his photos into paintings. While he watched Valien do all the work, Kippenberger enjoyed how the smell of paint mixed with the stage scenery. When the paintings were finished, he signed them with the name "Werner Kippenberger." From then on, he would frequently resort to the *"Lieber Maler, male mir"* method. He would take something that already existed and repeat it in combination with some-

thing else. The result would be a Kippenberger. This worked, since—as the gallery owner Sophia Ungers put it—he "treated the rules not as instructions, but as a guide to be constantly modified, transformed, defamiliarized, and coopted."

One of Kippenberger's poems went like this: "Since I've been here, gone, gone, gone." The open-ended two-liner can be read as a metaphor of his absence from his own life. By this time he was living in Cologne, whose informality he found more congenial. The easy-going city of carnivals seemed to offer a better platform. To understand how other people saw him, he first tried turning himself into an object. It was an undertaking reminiscent of Raymond Roussel's experimental method. Kippenberger, however, did not invent any machines that would write for him; instead he commissioned Annette Grotkasten, the singer from the post-punk band Bärchen und die Milchbubis, to write under his name an account of what he'd experienced. Grotkasten was to observe him. As a witness, she would objectify his subjective impressions.

Kippenberger took the train to Knokke, a seaside resort in Belgium. During the journey he recorded everything he did: all the food and drink that he consumed in bars, restaurants, and dining cars; the room he stayed in in the Hotel Carlton; visits to the cinema and to a disco. Some time later, Grotkasten repeated all his movements down to their smallest details. She sat in the train, went through all his experiences and wrote the book *1984— Wie es wirklich war am Beispiel Knokke* (1984—How It Really Was: The Example of Knokke), published in 1985. The observer's observations concentrated on the external world. Both of them avoided describing internal experiences, such as states of mind, feelings, or other such speculative profundities. In this, they were very much

children of their time, and not a little dandy. The narrative, in which nothing happened, laid bare George Orwell's prophetic vision of the future as an eventless year. It would be easy to dismiss Grotkasten's assignment as the narcissistic whim of a man who wanted a woman to serve as his mirror. But Kippenberger was a damaged person who managed to put his own need for attention to creative use. By accepting the rules of his directive, Grotkasten became both a witness to, and a voice for, the events inside his head. It is true that Kippenberger's name appears on the cover of the book. However, once he was made subject to a text, it was the ghostwriter who decided how he might have experienced the world. A marionette suspended from strings made of words.

The Female Gaze

In late 1985 Kippenberger travelled to Brazil. Albert Oehlen, his travelling companion, couldn't stand the Copacabana and soon went back home. Left to his own devices, Kippenberger felt lonely and invited the photographer Ursula Böckler to come out to visit him. When she opened the door of her taxi on the Avenida Oceânica, she was hit by a salty sea breeze. The concrete block of the Bahia Othon Palace was so tall that she had to strain her neck to make out the top of it. Kippenberger appeared from the entrance. He seemed as excited as a child, but looked like the post-punk double of the millionaire Gunter Sachs, weary of acting the playboy on the exclusive island resort of Sylt. As they travelled round the country together, going on trips, partying and playing cards, Böckler observed him with her camera. The grand total of all their Mau-Mau games over two weeks tells you who

was the better player: Böckler won them by 19,234 points.

On one of their trips they were driving along a coastal road when they passed a gas station with two pumps labelled *alcool*. Both of them immediately saw the joke. The pumps dispensed a fuel made from sugar cane, which could be used to fill up not only cars, but also human bodies. Wearing shorts, Kippenberger posed standing between the two pumps, with his backside pointing at the camera and the Atlantic Ocean in the background. However, his Pirelli calendar pose turned into something else. This model did not remain passive. He decided he wanted to buy the crumbling petrol station and rename it the *Tankstelle Martin Bormann,* or Martin Bormann Gas Station, after one of Hitler's most brutal henchmen. The gas station attendants watched as Kippenberger took a piece of chalk and wrote "TMB" on the bare concrete wall. Having decided the gringo had to be a bit crazy, they started laughing. What is astonishing about Böckler's photographs is how, despite the abysmal Nazi joke, they reveal Kippenberger's quieter side. The black and white pictures have an effect that is both distant and intimate. Her photographic gaze produced a softer image of her subject than the one that commonly did the rounds. Although Böckler emphatically pointed her camera at the man who fascinated and amused her, she did not do it to the exclusion of everything else; rather, she let places and buildings play an equal part. When she pointed her lens, Kippenberger would strike poses, as he always did when a camera was on him. But his poses were less exaggerated; he was less of the showman, and he did not pull any faces. Böckler often captured him surrounded by other events. Her pictures show how her subject could leap into passing moments and suck them dry, leaving them exhausted.

Despite his need to keep everyone's attention on himself, Kippenberger was very far from being the dauntless dandy, capable of walking through doors even when they're shut. He was too driven, and lacked the dandy's characteristic passivity.

Hiring Staff and Disintegrating

Cologne, 1987. The young man had been deeply involved in art for some time. Then one day it all became too much for him. After suffering a nervous breakdown, he wanted to keep this dangerous infatuation at a distance. He took up acting lessons, in the hope that it would teach him techniques for protecting himself. Having run though all his inheritance, he was skint and had to earn money. Becoming an artist's assistant seemed to be a way of getting paid to be outshone by someone else. He applied for the job and got it. His boss named his employee "Michi" or "MK1" and himself "MK2 (leading role)," as if they were performing in a play. What surprised Michael Krebber about becoming an assistant was how art now became really exciting for him. One of Krebber's first tasks was to put together a collection of books that every artist should have read. The selection, which he made with the help of the psychologist Friedrich Heubach, looked like a literary introduction to dandyism: Diderot, Baudelaire, Huysmans, Proust, Rigaut, Vaché, de Laclos; there were no Englishmen, and no women, but a few Russians, such as Lermontov, and Oblomov, Ivan Goncharov's famous idler.

Tenerife, a short time later. Kippenberger contemplated the pile of books he'd ordered. As a child he'd learned to behave as if he were reading on his own. It would draw praise from his parents—and he liked being

praised. Since he found reading exhausting, he had other people read for him. Many of the books could show you how to become a character. Those on which the script of his future life is based can be found listed in his 1987 novella *Café Central—Skizze zum Entwurf einer Roman-figur* (*Café Central—Sketches for Studies of a Character from a Novel*), which he either wrote himself, or which at least someone else wrote on his instructions. It was the beginning of a developmental novel that grew beyond the book form, one in which MK1 and MK2 dissolved the body of Martin Kippenberger into the multiplicity of individuals who would later speak through this name.

In the meantime, the Kippenberger business was going from strength to strength. More staff were taken on. Instead of showcasing the identity of a specific individual who did things in a particular way, the Kippenberger team synthesized connections and relationships. Despite its single brand name, it was art that resolved into a multi-plicity of different elements. The boss started absenting himself more frequently from the day-to-day manage-ment of the business, going to a health resort or hanging out in bars, where he'd chain-smoke Marlboros. Many believed that the employees could now do whatever they wanted. But the "fat spider," as Krebber and the artist Cosima von Bonin called him, knew how to hold the threads together; he was still the programmer of the pro-grams, which constantly built up expectations only to disappoint them again.

Give Us a Joke!

"Ich trinke Bier, so geht das nicht nur dir" ("I'm drinking beer, so it's not just about you"). When Kippenberger wrote nonsense aphorisms, and sent faxes of a strange bird, he unintentionally drew a connection with the origin of the expression "dandy" in the seventeenth-century Scottish nursery rhyme, *Jack-a-Dandy: a little foppish impertinent fellow.* Despite his well-cut suit, the artist, who could not be said to belong to the pantheon of dandies, did like to play the "impertinent fellow" when telling his over-long jokes. He called these punchline-free shaggy dog stories "artist's jokes." Their clumsiness and cringeworthiness came from their constant stalling of any liberating burst of laughter. They were jokes about telling jokes, and the point was to come up with the very worst of their kind. One of them began in a bar in Berlin. Its landlord was called Michel Würthle. Before the Paris Bar opened, he had run the restaurant Exil on the Landwehrkanal, together with Ingrid and Oswald Wiener. Its menu included baked calf's head, glazed tripe, and pickled tongue. As well as being a restauranteur and a dandy, Würthle was an artist, and one of Kippenberger's closest friends. That did not protect him from being mocked. When, in 1993, Würthle had his first solo exhibition in a gallery in Austria's Burgenland, Kippenberger decided to hold one of his endless table talks. His uninterrupted flow of words held out the promise of ending in a joke, but never did. Kippenberger seemed to have his material under even less control than usual, and lost his thread by insulting every conceivable minority, as well as the artist whose exhibition it was. Despite being attacked in this way, Würthle was not going to play the victim. He could give as good as he got;

one evening when the stranger at the next table was getting on his nerves, he picked up a fork and stuck it in his behind.

Four years after Kippenberger's early death, Andrea Fraser decided to re-enact his give-and-take of attraction and repulsion. The talk that had been recorded at the Club an der Grenze provided the text for her "enactment." The Galerie Christian Nagel had been converted into a stage; but even before she performed her re-enactment there, Cologne's art crowd had been expressing their concerns. Fraser wanted to do what caution advised against. By the precarious endeavor of impersonating someone who was extremely difficult to imitate, she was risking her good reputation. Wearing a dark suit and clutching a glass of beer, Fraser gave a hunched portrayal of Kippenberger, in which at times she seemed like a puppet suspended in front of abstract paintings. These crudely painted monochrome canvases took the title of her performance *Kunst muss hängen* (*Art Must Hang*, 2001) literally. Kippenberger had angrily flung these three words at Fraser after buying some punched metal smileys at her first exhibition at the Galerie Christian Nagel in 1990. When he'd tried to hang them on the wall of the Paris Bar, they'd repeatedly fallen off.

The recording allowed Fraser to learn Kippenberger's talk by heart. Repeating his phrases in a language in which she was not fluent, while reinforcing them with her clear diction, enabled her to present the person she was playing at a distance, in a manner that made him both clearly recognizable and artificial. For the audience, the impersonation was about as difficult to bear as the original. Many were wishing it would soon be over. One thing that relieved the atmosphere during Fraser's performance was the joke about a stuttering radio announcer who fails

to get a job at a radio station. He fails not because of his disability, but because of his Nazi past. For some people, the punchline—which was simultaneously chilling—was what saved the entire evening. They whinnied like a horse that was being broken in. Fraser was not interested in sending up a burnt-out provocateur, but in laying bare this dialog of gazes. It wasn't only Kippenberger she was scrutinizing, but the audiences who so avidly watched him. Nevertheless, the audience could only love Kippenberger once he was dead and no longer able to object when people shouted: Kippi is the utterly authentic narcissist I always secretly wanted to be.

everybody watches me
everybody puts me down
everybody wishes i were dead
(Bayer)

Andrea Fraser's performance as the embodiment of Martin Kippenberger is reminiscent of the relationship between intoxication and manipulation to be found in Wolfgang Bauer's 1969 play *Change*, which was one of the lesser-known influences on the Cologne Complex. While Bauer's plot is crueller than Fraser's, both offer a vision of art where everyone is playing with the rules but no single person is in complete control, with the result that agreements have to be constantly renegotiated over time. *Change* is set in the back rooms of the Austrian art world. The studio play presents a drama of conspiracy. Its victim is the hopelessly naïve Blasius Okopenko, who paints pictures with titles like *The Yellow Birches of St Pölten*. In the first step of the plot, a clique of bored art professionals relentlessly promote Okopenko to the point

where he becomes a star. Once they've successfully established the dilettante on the art market, they start preparing his downfall. The plan is to plunge their protégé into a mental crisis, and then get him hooked on drugs, with the ultimate aim of driving him to suicide. Everything goes as intended until, just as they seem on the point of achieving their goal, their victim calls a *change,* and the roles are reversed. At this point, Okopenko shifts from object to subject, and becomes the master manipulator. A wild party begins. And while everyone lasciviously falls on one another, the would-be puppet master, outmatched, retreats into a neighboring room and kills himself.

The man hanging in the bathroom was based on Konrad Bayer. Born in 1932, the writer was one of those who helped reintroduce dandyism to Austria—known in 1920s Vienna as *Gigerltum*—after World War II. Outwardly it amounted to his suit, the only one he owned. In it he could dance charmingly, never having to touch anyone. As Vaneigem put it: "It is only in counter-rhythm to the official world that you can learn to dance for yourself." When Bayer won some money at roulette, he'd catch a train to Paris and stroll around. He hid what ambition he had behind obtuse drinking games like *Mutti denk an mich* (Mama, think of me), which had only one rule: down the next brandy in one. Rather than admit to any ambitions with his writing, he liked saying that dying was the only thing left for him to do.

"that's amusing
that's beautiful
that's the end"

Bayer, who composed these lines, did not share humanity's more commonly held opinions of itself. Since the corollary was that people were, to an almost unbearable degree,

voraciously greedy, he preferred to ignore himself and concentrate on others. He would arrange his observations on their thoughts and feelings into scenes. Bayer seemed incapable of experiencing anything directly. He could not deal with intimacy. He found anything more than the most superficial interaction with others awkward and contrived. People might engage in physical contact, but in essence they remained isolated. This artificial way of relating to others was inspired by cybernetic theories, which he tested out in *in vivo* experiments. Bayer worked with Oswald Wiener, who had studied the science of controlling systems through communication, and together they would cause couples they knew to split up, or even worse. Their theories combined the cybernetic world view with that unusual form of social cooperation known in Vienna as *der Hass* (loathing), and a tendency to think in terms of feedback loops. The situations created by Bayer and Wiener ultimately led to an expanded conception of dandyism.

Having learned how to pursue strategies based on appearances, Bayer came up with the scheme that would later provide the plot for *Change:* Padhi Friedberger, a bohemian friend of his, was to be overpromoted as an artist, then knocked down once he'd reached the summit of his success. The aim was to drive him to suicide by destroying him psychologically. In the course of the experiment, the programmers lost control over the subject they were trying to program. However, the motives behind Bayer's suicide were more complex. You don't just kill yourself because you're surprised by the outcome of an experiment. In 1964 the German writers' organization Gruppe 47 invited Bayer to give a reading at a conference in the Swedish town of Sigtuna. After he'd finished, the organization's jurors, who clearly considered their judge-

ments to be oracular, didn't just trash Bayer's work, they very publicly staged his execution. Devoted to authenticity, the Germans didn't know what to make of the self-ironizing Austrian dandy. And what they couldn't understand should not exist. On the grounds that Bayer had also used Jewish-sounding names "for no justifiable reason," the judges of Gruppe 47 implied he was guilty of antisemitism. Erich Fromm, author of the 1956 bestseller *Die Kunst des Liebens* (*The Art of Loving*), delivered the coup de grâce by accusing him of being "anti-human."

Although he didn't like to make much of the fact, Bayer was Jewish. After this savage beating, he returned to Vienna, where he invited several friends to meet him at the Café Hawelka. It was apparently a pleasant evening. Feeling exhausted, Bayer did not join his friends when they went on to a night club; but he did get his girlfriend to promise solemnly that she'd come back no later than four o'clock in the morning. Then, on October 9, he went back alone to his flat in the Seidlgasse. There he put his head in the oven and turned on the gas. It proved to be a fatal wager. He might have lived, but his girlfriend danced until dawn. By then Bayer was dead.

Some people said that it was how he would have wanted things. He'd written any number of lines such as: "you have to kill yourself in order to bury hope." Other people argued that he'd taken his girlfriend's promise to mean that her behavior was predictable, and it had not worked out as planned.

Suicide, the act of absolute power over one's own life, deserves more attention here, since many dandies have chosen this way out. But I find I lack the words for it. All I can say is that no one approves the act of taking one's own life. That would be asking too much. But as Jean Améry has noted, it would be a terrible presump-

tion to pass judgement on those who commit suicide, given that we spend so much effort trying to avoid death.

One Friend Develops the Other's Ideas

After Bayer's death, Wiener developed the psychological experiments they'd worked on together a step further, until he came up with the notion of artificial intelligence. In *"Eine Art Einzige"* ("An Ego of Her Own," 1982), a short treatise written two decades later, he drew a direct line from the dandy's act of self-creation to the artificial intelligence machines used to imitate human thought. In this work, Wiener did recognize a machine-like character in the psyche, but he conceived of it in a somewhat different way. It was true that its dynamics could be described in technical terms, and Freud had already done so with his metaphors taken from the world of steam engines, such as repression and suppression. But in reality, psychic structures consistently failed to function this way. Wiener's comparisons established similarities as well as differences with the dandy: artificial intelligence, the technological imitation of the human mind, resembled the modern ascetic in that it perceived its environment more in terms of structure than of content. Like a program copied from the mind of Monsieur Teste, artificial intelligence processed data without formulating opinions. Like self-observing dandies, artificial brains treated everything with indifference. Nevertheless, there was one crucial difference: dandies reacted to what they had indifferently observed by doing things that no one expected. They expressed their astonishment by bewildering others. AI, by contrast, behaved in precisely the opposite way. Its filters limited what it perceived to what it knew,

reduced the unknown to something already known, and reacted to everything with a predictable indifference. Its pre-programmed automatism meant that machine thinking was incapable of being surprised; its reply to everything was: I know that already. It had no concept of astonishment. From observing the stubborn conservatism of machines, and how they related everything back to what they already knew, Wiener concluded that if there is any chance for freedom to exist in a cybernetic reality, then it would be in the stance taken by the dandy, who continuously abandons the identity he has just embodied in order to pursue new and unexpected forms of behavior. Even Wiener tried to abandon the person he was meant to be in order to surprise himself as another. This is why the writer's biography retrospectively reads like a novel whose hero constantly manages to defy expectations.

The Long Goodbye from Oneself

In the post-war years, the young man played trumpet, performing in the night clubs of Vienna, the city whose name he bore. His school friend and fellow musician Konrad Bayer introduced him to a circle of poets and artists. He started writing and joined the Wiener Gruppe, a gathering place for the city's avant-garde. Things went well for a while, but then he got sick of it. The arrogance of his friends, and their subtle pecking order, all that started to disgust him. Moreover, he felt a nagging sense of inadequacy as a writer. Finally, there were the financial pressures he faced as the father of a young family. Wiener gathered up everything he'd written and threw it on the fire. He watched the words he now scorned turn to ashes amid the glowing coals. As a snub to his old friends

and their smug prejudices, Wiener chose to become a salesman, selling sample programs for office vending machines. He embarked upon the miseries of a petty bourgeois career. This decision to live the wrong life opened up new opportunities for him. Wiener was promoted despite himself, and ended up becoming part of Olivetti's management. There, he hated the work more with every passing day: the profiteering, the expensive cars. In order to make the horror of a successful life bearable, Wiener started writing again, this time with increasing savagery. He would place a sentence on the desk and smash it with a hammer, as if it were a soft-boiled egg. And if the splattered sentence didn't produce enough of a mess, he'd hit it harder. Once never seemed to be enough. For him, language was a cypher for everything that seemed out of kilter, and merited nothing but loathing.

Again, it was Bayer's urging that set him on his journey into the depths of the destruction of language, which eventually grew into the monstrous text *die verbesserung von mitteleuropa, roman* (*the improvement of central europe, a novel*, 1969). Relentlessly his friend kept pushing him to write. Following Bayer's suicide, Wiener's writing accelerated to a manic pace. He was now vomiting out words. Amid the convulsive sentences, dark forms rose up like shadowy ghosts. Wiener's struggle with language led him to a sinister vision of what would one day be called the Internet or cyberspace, but which at the time existed only as a vague idea of what was to come. From his writing there emerged a vision of the indestructible network of the future as a happiness helmet that granted every wish. Once placed over the head, the "bioadaptor" offered everything one could wish for; no desire was ever frustrated, and the mind was guided to a place where everything was as one hoped it to be. An illusion of plenitude,

which inflated the wearer's ego to an astonishing degree by constantly satisfying his or her every wish in this safer space. It functioned by filtering out those things consciousness didn't want to see. Wiener's science fiction anticipated the technological policy of separation for which the term "filter bubble" would be coined thirty years later. In filter bubbles produced by algorithms, people would only ever be confronted by their own opinions. Feedback from their own desires would become the driving force behind the privatization of the political, transforming every attempt to deal with common problems into a non-dialog among solipsists.

Wiener's pessimistic vision of the bioadaptor anticipated something of the technoid future imagined in Gilles Deleuze and Felix Guattari's *Anti-Oedipus* (1972). In it, human beings are made to "'fight *for* their servitude as stubbornly as though it were their salvation.'" Wiener's bioadaptor was a kind of spiritual forerunner of the "desiring machines," apparatuses that coaxed human desires from bodies, only to keep them on a short leash by providing them with a constant stream of the mere semblance of satisfactions. To guard against being held captive this way, Deleuze and Guattari invoked Artaud's image of a body without organs, whose tightly stretched skin repelled everything that threatened to penetrate it. In many ways this impossible creature resembled the dandy's volatile surface. To be a dandy is to seek a space where one can be free. To keep their bodies suitably volatile, dandies experimented incessantly with provisional personalities, regarding these as incomplete reflections of themselves. Of them, Wiener wrote: "I have always tried to see myself through the eyes of others, and have found a great deal that I don't remotely like."

A Parrot Bites into Glass

Change was made into a film in 1974, riding on the crest of the sex wave. The result was a hard-edged, risqué piece that was a hit. The film is said to have been rediscovered in a basement in the mid-1980s. It then passed in VHS form from hand to hand among young painters. The drama of the conspiracy resonated at a time when the art world had run out of ideas, and was merely stumbling from one fashion to the next. The film's play of personalities offered a foretaste of a second wave of institutional critique, art that, only a short time later, would dissect the mechanisms of the art world. As an uproarious analysis of the system, *Change,* like the work of Michael Asher, had the effect of a crude bar joke.

In 1986, Michael Krebber showed the film at the opening of his first solo exhibition in Hamburg's Fettstraße 7a. Krebber's debut was given a glowing introduction: in an article published in advance in a local magazine, Albert Oehlen promised that a "fifteen-year-long staging of his own failure" would soon come to an end, adding that, "now, for the first time, his pictures will not end up being thrown in a garbage bin." This promise was not kept. The exhibiting artist showed only one painting. He could not be responsible for any more than that, since every picture ran the risk of becoming a piece of furniture. However, one picture seemed to be enough. Krebber had a talent for appearing to have a great talent. For a while, the game of disappointing expectations went well; but eventually he found himself under enormous pressure. Hundreds of people were watching and waiting for him to deliver on his promise. To deflate expectations a little, Krebber took refuge in the image of Marcel Broodthaers's parrot—the bird that repeated everything

without actually being able to speak. As a self-described parrot, he repeated other people's painterly gestures. Gestures which, according to many people, belonged to such predecessors as Baselitz, Guston and, most frequently, Polke. While repeating these things, he would chain-smoke Roth-Händles. It was said he reached for a cigarette more often than he did a brush. He rarely hung a painting himself. If he did, it was generally something that had been abandoned at the earliest possible opportunity. Was it procrastination? Krebber liked to leave open what he was going to do next. There was talk about the painter who painted very little, and who would exhibit empty rooms as if they were abandoned cages. Some condemned his practice of leaving spaces empty, others considered it lazy or pretentious, and still others reacted with anger. However, quite a few people also admired this "provocateur of the first rank," as Oehlen called him. Krebber liked to disappear, but he also liked to divide opinion. And if your work amounts to something more than the mere expression of a private religion, it is going to be condemned. He wasn't interested in painting ideas, he wanted a language that would strike people like a physical blow. Anyone wounded should return fire. This will to confrontation, which drove Krebber to provoke others to the point of rage, could mean licking a car bumper, saying "I despise you" to someone, or biting into a beer glass. But who can swallow pieces of glass? A body without organs? A dandy? And hadn't that long been an excuse for anything and everything?

The Scent of the Living Dead

As early as 1982, Wiener had already observed that "a high-class dandyism is no longer possible; it can only be repeated as something subordinate, a *subculture*." Krebber responded: "The trouble is that so many people have to find out for themselves that the earth is round." He understood his relationship to the dandy to be that of an apprentice. Dandies themselves didn't need art; but anyone wanting to make art could learn something from them. To get closer to the undead, Krebber designed a model world: the sealed glass cases he showed at the Galerie Christian Nagel in 1990 functioned by excluding visitors, leaving them shut outside. Inside these closed spaces, Krebber displayed a unique collection of catalogues, documents, and devotional objects. Several cases alone were dedicated to Dan Graham. Alongside him were John Knight, Balthus, Pierre Klossowski, Daniel Buren, and Michael Asher, all of them artists exhibiting a dandy-like behavior that until then had not been recognized as such. The glass coffins contained artistic stances awaiting reanimation, like Snow White. The dandy now hung about the room like the scent of a perfume. However, there were many scents in the Haus der Kunst. The seven dwarfs seemed bewildered, and Krebber, who held in his hand the bottle of dandy perfume, was himself a rumor. An artist's artist, an unavoidable challenge to others working in the same field, and to the rest of the world invisible.

Hi guys
I am the observer.
I stand silently up here and simply exist.
I have nothing to say.
I pass no judgement.
I simply watch as things come and go.
(Schamoni)

M. Teste was painted in 2003. Fabric mounted on a stretcher shows an image of a horse galloping against a full moon. It is the Monsieur, rushing precipitately towards his secrets. Five years later, Krebber made another reference to Monsieur Teste, this time by spelling out, in front of Cologne's Kunstverein, the name "Herr Krebber" in letters reminiscent of the famous Hollywood sign. Krebber's copies of them formed a signature to the show's title, *"Pubertät in der Lehre"* ("Puberty in Teaching"). The exhibition posed the question of what would happen if Monsieur Teste travelled to California to reflect on what sculpture might be. The result was sawn-up surfboards, lying on the floor or hanging from the walls as if someone had turned a shoal of plastic sharks into sushi. Did Krebber want to examine something that had never before been examined? Did he want to dissect in order to understand? Or had the demon rendered the boards useless in order to sabotage himself?

During the exhibition, the investment bank Lehman Brothers collapsed. It was the beginning of a global recession, which set off a series of chain reactions leading to other crises. With the financial crisis of 2008, a tremor that anticipated our current crises, a new era in art began. Suddenly it was considered cool to work. Now everyone was working all the time, and wanted to show how hard they were working. The visibility of drudgery took prece-

dence over everything. Projects came into fashion and stayed that way, like ripped jeans. People wrote applications, set themselves goals, and researched knowledge gains. The art of late neoliberalism was supposed to do more than simply exist, it was also supposed to do some good. It served purposes, and quite often it wanted to make the world a better place. From the old dilapidated factory there emerged a streamlined industry. With their gazes turned towards the future, the initiators of these projects kept a constant eye on their competitors, while never ceasing to tell each other whether they were meeting their goals. As their well-informed gazes blinked wearily at half-empty plates, they affected a hunger for the new to distract people from the fact that they'd never filled a plate themselves. The people sitting at the table only knew how to ask for more without saying thank you. But at some point
somewhere
somehow
it becomes clear that they still hadn't finished their soup. I wrote on my napkin: the new doesn't interest me.

A Dandy in Bern

Flashback: January 9, 1991. Bern can get very cold, thought
the man as he bit into his club sandwich. He shut his eyes
and asked himself what he should do next. At first he had
written to them with questions, such as: which countries
and cities does Swissair fly to, or where are the local rec-
reational areas in Bern? Instead of replying, *are you sure
you're all right?*, they answered with all the reliability of a
Rolex watch. At some point he travelled to the pretty town
unannounced. On arrival in the self-obsessed mountain
country, he first alighted at the Schweizerhof Hotel. Grace
Kelly had said it was the place to be. The schnitzel was
really good, but the smell of the scented soap was so
overpowering that strangers could tell where he was stay-
ing. Since he was feeling a bit depressed, he got into bed
and read John Le Carré's *Smiley's People* (1979). While
still devouring the thriller, Michael Asher moved to the
Hotel Bellevue Palace, described by the novel as being
especially comfortable. In fact, the waiters did not unfold
the napkins on the guests' knees quite as attentively as
the book claimed; but he could watch the building on the
other side of the river through the window. Asher shifted
the curtain a little to one side and asked himself whether
art wasn't in fact a prison. If it was, it was a particularly
comfortable kind of penitentiary. He tucked his Brooks
Brothers shirt into his pants and left the room. On enter-
ing the hotel lobby, he felt the need to tweak his but-
ton-down collar. The DJ had just started playing a lounge
version of "Surfin' USA." The Christmas tree was still up,
and few well-camouflaged prostitutes were dancing
round it, but Asher's thoughts were on the Kunsthalle's
main hall. Here were all the distractions of a thousand
armchairs, carpets, pictures, bronzes, the entire porcelain

HALL

collection, the conspicuous bouquets of flowers, and the huge quantity of selected knick-knacks; he, by contrast, would simply leave the main hall empty. A gigantic cube without anything ... then came the interruption. A nervous agitation flowed through the room. Bodyguards were reconnoitring the hotel, as the manager prepared to greet a prominent political figure at its entrance. Was it Kashoggi? The excitement filling the air delighted Asher. The room felt as if it were thoroughly overheated. Once things had calmed down a little, he ordered another white tea and returned to his thoughts. As in any system, the challenge posed by the Kunsthalle Bern lay in the degree of disorder among its molecules, whose state of confusion ensured that, sooner or later, they would die a heat death. To prevent a descent into chaos, he needed, like Maxwell's Demon, to establish order among its molecules. It was this thought experiment, derived from physics, that had led Valéry to the figure of the invisible observer Monsieur Teste; Asher now realized he could return it to its original conception as a mechanism that would be able to sort molecules according to how warm or cold they were. However, Asher's demon did not stroll invisibly though the city while observing itself. It functioned like a magic trick, transforming a familiar room into a different space: to realize this demonic institution machine, he came up with the idea of reconstructing the Kunsthalle's heating system. By relocating its radiators, he could transfer the molecules into a permanent state of division. This would establish an order that maintained itself automatically. The miracle, the organizing machine, was easy to conceive: all the building's radiators would be moved from their existing locations to the Kunsthalle's lobby, where they would form a little Celtic village. There their function would be what it had always been: to heat

the space around them. Changing the circulatory arrangement would have the effect of creating a receptacle for the warm molecules in the entrance hall, while the other six exhibition rooms without radiators would be transformed into containers for the cooling molecules. As a model of a stable system of molecules, the conversion would assume the role of the Kunsthalle's organizing observer; an automatization of his self as a Maxwell demon bringing order to the institution. A draft of cold air was now blowing through the revolving doors. He swallowed the last of his tea and went back to his room. The next morning he ordered a taxi and drove to the airport. On the plane, he dreamt that his surfboard back home had been sawn into pieces while he was away.

It would take until 1992, almost another two years, before his Kunsthalle operation could be realized as planned. It was an astonishing exhibition. Never before had someone intervened so drastically in the building while at the same time managing to appear so absent. Though no one noticed it at the time, Asher succeeded in translating the dandy's self-reflexivity into art. A dandy machine that wandered about like a ghost in a machine. Or did I just dream all this?

Nightmare on Wall Street

Baghdad, January 17, 1991. In the middle of the night, a coalition of countries led by the United States bombed Iraq. In what were often described as surgical strikes, the attackers sent down remote-controlled prostheses from the skies, in a bid to bring an end to the rule of a supposed psychopath. Those being bombed had no way of defending themselves against an opponent who remained

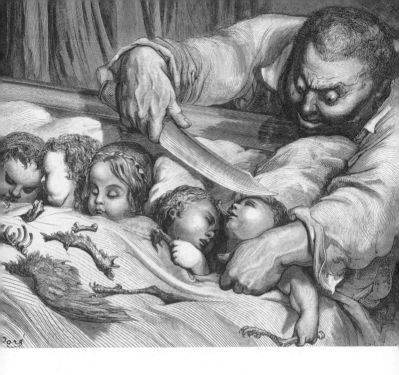

invisible. It was an intervention that marked the beginning of an epoch of asymmetrical war, which would later come to be known as the "war on terror."

American Psycho was published two months after the beginning of Operation Desert Storm. The novel presented the most brutal caricature of a dandy that had existed until then. Its author, a child prodigy called Brett Easton Ellis, lived in a house on 13th Street in downtown Manhattan, in 1987 still a down-at-heel neighborhood. Tom Cruise lived in the same building. Both Ellis and his central character, the American psycho Patrick Bateman, would frequently meet the actor in the lift. Nevertheless, Ellis was not Bateman; no one here was anybody. Nor was he remotely interested in being anybody. He was interested in the question of how far repetition could be taken, and in the stylistic issue of whether madness can be described without naming it as such.

The first 114 pages of *American Psycho* deal with the boredom of living life out of a mail order catalogue. Bateman lurches through the void of a commodified world, looking like the besuited silhouette from Robert Longo's 1980 series *Men in the Cities*, which hangs in the investment banker's apartment. It shows a man wracked by convulsions, his movements reminiscent of the tropical disease known as "dandy fever" because of the strange gait of those afflicted by it. But the dancer is not suffering from dengue fever. He is a flashback to the New Wave-style cool with which Bateman and his friends would cut lines of white gold with their platinum-colored AmEx credit cards, seeking the inspiration needed to unleash the power of markets. The novel is set in the months before October 19, 1987, Black Monday, which would go down in history as the stock market crash that shook the world. A consummate dandy, Bateman has all eyes upon him-

self, and is a monster dreaming in front of the mirror who confronts the present with his ecstatic truth. Although repulsive, he is a monster who loathes the same life that's tormenting us; and this instills an intimacy with his character that the reader has great difficulty acknowledging.

On April 1 of that year, while Andy Warhol was being buried in St Patrick's Cathedral in New York, Ellis sat down on a park bench and wrote in his notebook the first lines of *American Psycho*. The death of the artist who had embodied the American dandy like none other marked the end of an era in which art still derived from hidden, underground currents. Now, as the world collapsed, everyone was trying to look good on the surface. It was still unclear, in the summer of 1987, how a dandy would be able to distinguish himself in this atmosphere.

Bateman, the poor little rich boy who looks as if he had his last shave about an hour ago, puts his money on a theater of cruelty, thinking: "do what thou wilt shall be the whole of the Law." But what did this mean, apart from repeating Aleister Crowley? What kind of subjectivity could still offer resistance in a world of rampaging ego-machines? Initially no more than one snob among many, Bateman is transformed into a killer by his determination to be different. Murdering people with a chainsaw poses no qualms for him. His bloodlust gives him the feeling that he is really alive. Of his friends he thinks: you are boring, but I am thrilling. And yet all he can do is re-enact scenes from the 1974 horror film *The Texas Chain Saw Massacre*. Bateman's determination to be different amounts to nothing more than repeating something else. The coming-of-age novel about living a privileged double life in New York was inspired by a *fin de siècle* novella by Joris-Karl Huysmans. Bateman's story becomes a retelling of the life of the decadent writer Durtal from

163

Huysmans's 1891 novel *The Damned* (*Là-Bas*). Born of the shock of the industrial revolution, this fictional character dedicated his life to the study of Gilles de Rais, one of the most horrific serial killers ever to live, who in the Middle Ages tortured 150 children to death. Having noted Rais's atrocities, Ellis rewrites them as crimes committed by Bateman, although the American psycho kills women instead of children. These acts of appropriation become part of the distorted self-image of someone who is trying to find himself by engaging in hands-on murder.

The investment banker experiences the alienation of his postmodern life as a personal insult. The killings, which are described in salacious detail, are his way of resisting it. Chopping people up becomes Bateman's vision of an authentic life, in contrast to the inauthentic one in which people become obsessed over who has the best business card. Bateman's card has the name "bones" on it. But every time they compare cards, someone else has a more elegant one that trumps his. To compensate for these defeats, he strenuously works out in his apartment during the day, before wandering about it at night amid shiny espresso machines and blood-stained bodies. After dismembering his victim with a chainsaw, he imagines he's winning the next round when he manages to get a reservation at an exclusive restaurant.

Monkfish with golden caviar
Mussel sausage
Meat loaf with chèvre and quail-stock sauce, tinted pink
by pomegranate juice
Red snapper with violets and pine nuts
Peanut butter soup with smoked duck and mashed
squash

American Psycho colors Huysmans's black dinner from *Against Nature* (*À rebours*, 1884) with gradations of blood red. The loner who grows orchids on the edge of the city is reconceived as a Wall Street psychopunk, becoming a symptom of the crisis of the great stock market crash in the fall of 1987.

In this maelstrom of pastiche, Bateman vomits up onto the carpet all the rules of the dandy in one long stream. The sounds of retching accompany the carnage like overwrought muzak. The only witness to this long-drawn-out scream against the catastrophe born of industrial modernity, the "no future" feel of punk, is a blood-stained safety pin, which is used to fasten the plastic cape that Bateman wears over his freshly pressed Valentino suit. He is an ominous harbinger of the horrors that are soon to burst through the surface: the American military's torture centers in Iraq, the penal colony of Guantanamo, and the execution of enemy commanders by drones.

New York, April 14, 2000. Nine years after *American Psycho* set off on its kamikaze flight into international bestsellerdom, Mary Harron's film adaptation of the novel came out in the cinemas. In the opening scene, a tracking shot through Bateman's apartment shows several of Allan McCollum's *Plaster Surrogates* (1982–89). Together with an assistant, the appropriation artist had produced huge quantities of these user-friendly, slightly varied monochromes, which look like IKEA versions of Kasimir Malevich's *Black Square* of 1915. In a situation where everything appeared as a substitute for something else, this "plaster surrogate" of an icon of modernity had become a kind of super-signifier for contemporary art. In the film version of *American Psycho*, the *Surrogates* mutate into a backdrop for someone who imitates his models by chopping his victims up into little pieces. One of the few women

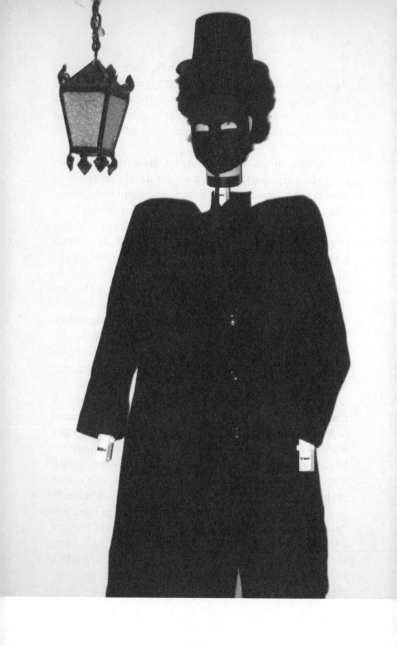

to survive a visit to his apartment is Bateman's secretary Jean. A chance phone call prevents her from being finished off with a bolt gun. Jean is played by the Miu-Miu model Chloë Sevigny.

Decadence of the Political

New York, September 11, 2001. A few months after the premiere of *American Psycho,* Sevigny played the leading role in the video *Get Rid of Yourself* (2001–3). This anti-documentary by the artists' collective Bernadette Corporation opens with a surreal sequence. A camcorder shot taken from the roof of number 183, 8th Street in Brooklyn shows the Twin Towers burning against a blue sky. It is intercut with shots of sunsets taken elsewhere. Are the towers really burning? Or was it all just a film in our heads? Jean Baudrillard would later write: "That the entire world without exception had dreamed of this event, that nobody could help but dream of the destruction of so powerful a Hegemon—this fact is unacceptable to the moral conscience of the West." Many people thought the sociologist was mad. Since that morning, it has become increasingly difficult to hold such unsettling points of view. In the wake of the insecurity ushered in by the attacks, an atmosphere of oppressive self-righteousness has prevailed. It marked the beginning of a period in which people stopped listening to each other and started more tenaciously asserting their personal opinions, convictions held without any basis, which came to be taken more seriously with every passing year. The notion that discussion should involve the exchange of views and the definition of different opinions collapsed. As the doctrine of personal conviction became more widespread, people ceased to

resist the proliferation of what went by the name of fake news and conspiracy theories. Instead of dealing with problems collectively, and engaging in discussions that could properly be described as political, societies retreated into the recesses of individual opinion, where they became ever more aggressively entrenched within their own filter bubbles.

In the opening scene of this one-hour video, the burning monuments morph into a virtual Rorschach test in the sky. What follows seems at times as if it could be a documentary shot by autonomists demonstrating at the G8 meeting in Genoa the same year. Attention is focused on the Black Bloc, that strategic concentration of discontent. Since the early 1980s, these masked militants have been trying to reinvent the idea of the revolutionary subject, by causing it to disappear into the black box of a collective body.

The shots of street fighting are intercut with scenes showing Sevigny learning her lines in the kitchen. By playing herself, the actor poses the question of whether in the future politics will be possible at all, or what it means to destroy an ATM. A series of disturbing images follows. A faceless model hobbles across the screen wearing a single boot. I am reminded of the phrase from Tiqqun: "Fog makes revolt possible." At the turn of the millennium, the Paris-based journal, which was involved in the production of *Get Rid of Yourself,* had described the battle lines of the coming insurrection, whose strategy would consist in obscuring its own intentions.

Cut. A man sitting under a tree is commenting on this idea. Something is wrong with his face. His skin hangs down in soft folds, and his nose and cheeks are covered in boils. The afflicted man—whose name is Werner von Delmont—is the alter ego of the artist Stephan Dillemuth.

He smokes a pipe as he reads the paper. As this time traveller from the age of Rococo reads out the headlines, he shakes his head. Does he do this because he disagrees with them? Or is this a tic? In the next sequence, he delivers a monologue to the camera in which he asks if these young people could possibly do with a bit more strategy, before puffing on his pipe again. What initially seems like a rather outmoded piece of advice actually predicts the paralysed state of shock that the anti-globalization movement would fall into following September 11. To this day it has not recovered from it.

In *Get Rid of Yourself,* no one shows their face; or rather, they show a face through which other voices are speaking. Are these rites of self-effacement now the latest return of the dandy? Once, revolution meant losing one's face in order to attain another world. But how are we supposed to get rid of ourselves in a reality where everyone is perfectly alienated?

Show me what you're afraid of
And I'll tell you who you are

Postmodern theory held out the promise that everyone would be able to invent who they wanted to be. After September 11, all that remained of this was the opportunity to choose what one feared most. Today, twenty years later, it is rare even to choose one's worst fear. They come preset, delivered free to our doors. Recurring panic attacks have become something like a fashion. One season I avoid using plastic for fear of degrading the world's oceans; the next spring I accumulate sackfuls of plastic rubbish for fear of the virus. It has become a quality of contemporary crises that they behave like fashions, temporarily mobilizing affects that cause me to live by one set of rules one day and abandon them the next. Nuclear power comes in and out of fashion like long and short pants. Every fashion dies, but once dead it returns as a zombie. The return of the living dead takes place with the greatest of ease. The old black returns as something new, and everyone leaping back into it is fully aware that this fashion, too, will die. Since the crises of fashion have become so similar, sales of electric cars and vegan meat increase so people can appear to conform to something while remaining formless. The original meaning of the word "crisis"—a decision in a moment of danger—has become narrowed to a choice of what to consume, so that the climate becomes last season's problem once our inflamed affects have subsided. What am I to do with this spiral of attrition, other than buy things? In a state of cool detachment, which allows me to repel the bombardments of affects? As a dandy with no opinion, who remains firmly indifferent to the twists and turns of crises, and casts his own fears to the winds?

Yankee Doodle Dandy

On this day in late winter 2005, the skies over New York were blue. The crispy duck was still hanging in the restaurant windows, and East Broadway still looked like an abandoned film set. The idea that New York is in a state of constant and rapid change has always been a shallow prejudice. For decades the silent film cinema at the end of Canal Street had stood empty. And nothing about it would change in the next seventeen years either. A gaunt-looking guy in a Yankees cap loitered at the corner. He was handing out small slips of paper to passers-by, on which was written: "open a door, hang a sign over it, and then go on vacation." I asked him where he would go. In a strained voice, he replied: nowhere.

It did not rain that day, but the dark cloud of lost invulnerability lowered over the city. The traveller going nowhere wrote regularly about art, but refused to call himself an art critic. He also refused to call himself an artist, despite having had numerous exhibitions. He wandered through life without arriving anywhere. Together with Emily Sundblad, John Kelsey had set up an art gallery. It did not come out of nowhere, but was a continuation of a story that had been woven together from several different strands. Its name was Reena Spaulings. Its story came from another story that originated in yet another. Nothing came from nowhere. Reena came from an idea of Bernadette's. But who was Bernadette? The ghost that had been calling itself Bernadette Corporation for the previous ten years seemed to offer the perfect alibi for never getting too personal. The loose group, which Kelsey had run into at some point, preferred to leave it an open matter whether it was composed of bored youths, fashion victims, a new type of concept art, or the return

of the dandy as a multiple personality.

After the shock of September 11, it initially remained unclear whether Bernadette Corporation would survive. It seemed difficult for such porous constructions of subjectivity to exist in a time of increasing surveillance. After making *Get Rid of Yourself,* part of the collective dandy went on to create a fictional character. As the invention of several different people, Reena Spaulings formulated a way out of the prolonged stalemate. Bernadette Corporation now professed to have transformed itself into a female writer, a receptacle that could be filled with a collective imagination. Sunsets remind Reena of funerals. The fictional character finds the dying of the great light to be extraordinarily beautiful, but is glad it only lasts a couple of minutes. At the end, Reena strolls back home and uses her last eggs to cook the perfect omelette. To digest it, she sleeps for two days straight, until she is woken by the birds. She dreams of her friend Maris being buried by a falling building. Reena takes this as a signal, and goes looking for her. It doesn't take long before she finds her. She is fine. Now it's Maris who's concerned because Reena is not eating her crab cocktail; she keeps on asking her friend whether a dream has made her anorexic, or whether she is taking drugs. Eventually Reena swallows the cold, plump creatures one by one.

Reena does not embody any kind of recognizable dandy, but in a time when everyone is supposed to play someone, she does convey the idea of not having to be anyone. On the last page, the collectively written ghost is transformed into a female gallery owner composed of several different people.

A Number One the Easy Way

Paris, fall 1959. At the opening of the Gallery Reena
Spaulings in New York, Kelsey handed out photocopied
booklets containing passages from *All the King's Horses*
(*Tous les cheveaux du roi,* 1960), which he had just trans-
lated from the French. Like Reena, Michèle Bernstein's
novel was the attempt to write her own story instead of
leaving it to someone else. Initially it had been an attempt
to reproduce the hit qualities of Françoise Sagan's suc-
cessful coming-of-age novel, *Bonjour Tristesse* (1954). But
as she wrote it, Bernstein's attempt to imitate a popular
novel ended up developing in a different direction.

It all began when Guy Debord took a look at the
parlous state of the household's finances and thought: if
an eighteen-year-old girl like Sagan can write a bestseller,
then my wife Michèle should easily be able to do it. To
Bernstein, who considered herself a "greedy and devious
girl," her husband's idea seemed like an enormous joke.
And why, asked the young woman, who cast horoscopes
to pay the rent, shouldn't a chance to have "butter on our
spinach and margarine on our broccoli" not be fun for a
change? After a prolonged perusal of the contemporary
market for literature, she sat down at the kitchen table in
the couple's little flat in the impasse de Clairvaux. Since
she didn't think of herself as being possessed of a power-
ful imagination, she wrote about real life: in her autobi-
ographical novel, Debord becomes Gilles, and she, the
first-person narrator, Geneviève. When she sat down at
the typewriter Bernstein thought, Situationists shouldn't
really work. And yet writing using passages stolen from
other works seemed to her to be lazy in the best sense of
the word. Bernstein would skillfully hide false bottoms in
the couple's *amour fou.* Not only did she write elegant

sentences with proficiency, *All the King's Horses* amounted to a contemporary retelling of Choderlos de Laclos's 1782 dandy classic, *Les Liaisons Dangereuses*. Bernstein transferred the epistolary novel about a strategic game of seduction from its original setting amid a degenerate aristocracy to the bohemian lives of the S.I.'s inner circle. The result sold decently. With her second book, *La Nuit* (1961), Bernstein definitively wrecked her emerging career as a novelist. Not only did she tell the same story all over again. She also put the grammar of her writing through a meat grinder, pushing her sentences to the limits of readability. Every machine has a function. A meat grinder grinds meat which is used to fill sausages. But who eats sausages, when they've tasted filet? No one wanted to read the jumble of past, present, and future a second time. Bernstein had intended this rehashing of her novel to fail. Every flight of ambition had to be shot down. Eventually she looked for a job in advertising. The dirtiest work seemed to be the best.

Tous les chevaux du roi is one of the finest texts ever produced by the Situationist movement. But for years the historical record, which embraced the belligerent masculine tone of the barricades, ignored both the novel and its author's literary suicide. The fact that Bernstein's books did not gain the attention they deserved wasn't just a case of a dandy staging her own disappearance. It was also the story of a woman who, like so many, had never gained the self-confidence to take what she wrote seriously.

John Kelsey saw translating as something he could either take or leave. No job ever seemed the right one. What else could you do, apart from keep changing jobs? This volatility, which Kelsey borrowed from the dandy, was not to be confused with flexibility, that much-invoked phantasm of the post-industrial subject. By painting in watercolors, he was following rigidly in the footsteps of his grandfather and uncle. It did not involve any kind of self-realization, and he called it work; he was repeating the leisure activity of his relatives. Like a character in a novel by Philip K. Dick, he gave a twist to his inherited hobby by watching himself paint as if he were someone else. To do this, he had to work himself into a state of extreme boredom. In order to paint the series *Dans la rue* (2016), he created an entirely artificial situation by shutting himself up inside his studio. Once inside his cell, he'd whisper, "someone had to introduce the genre of the street fight into watercolor painting."

In the nineteenth century, Karl Marx had dreamt of a future in which machines took care of all the work, so human beings could spend their time hunting, fishing, or painting. Reena Spaulings—whose emergence as an artist was animated by Kelsey and Sundblad, the painter Jutta Koether, and others—developed this idea into the question: why shouldn't robots, who do the greater part of the work today, also hunt, fish, and paint, so they can live less alienated lives? Or was this simply a fallacy, like the notion that robots and androids felt the need for love or longed for revolution? To find the answer, Spaulings let a machine paint some pictures instead of doing it herself. When she was younger, she'd imagined that being a painter involved hanging out in fashionable restaurants

like New York's Indochine and doing next to nothing. People would pour you glasses of wine, and serve dinner when you were hungry. Life in a restaurant looked like a promise. While the waiters bring in another course, an enormous machine is churning out the paintings.

Half a century earlier, the Situationist Giuseppe Pinot Gallizio had used painting machines which he'd built himself. Spaulings went a step further by using a ready-made domestic appliance. Its vacuuming and scrubbing functions were used to dispense Farrow & Ball paint. Spaulings had the creeping drone-like machine smear abstract seascapes onto canvases spread across the floor of her studio. The Scooba 450 was an assembly-line-built, floor-cleaning robot, whose special feature consisted of a fresh-water tank, which enabled it not only to clean floors, but also to kill 99% of all known bacteria. Despite this, canvases from the series *Later Seascapes* (2014), a homage to William Turner's late work, have a distinctly grubby appearance. Even expensive wall paints in colors like Mouse's Back or Smoked Trout made little difference. While Spaulings was aware that she would be observed while painting her abstract landscapes, the creeping robot didn't mind if anyone watched while it worked. All that it knew from its feedback loops was that you've already done this bit, you don't need to clean it again. The mechanical, zombie-like manner in which the automaton spread paint across the canvas seemed to offer a chance to take a break from painting, while the robot got on with the work with all the cool detachment of a dandy.

Passivity, not Picasso

The will to creativity is one of the greatest problems we face. Humanity is drowning in all the filth it's producing. The nightmare of overproduction is an argument for the dandy. Dandies leave only the lightest of footprints on their environment. They have no intention of growing, and have scarcely any interest in things that are supposedly new. Their skepticism about our constant reinvention of the wheel predisposes them to repeating what seems tried and tested, and to a love of indolence. While many dandies create next to nothing, there are some whose passivity generates an immaterial opulence. An antithesis to the dandy was Pablo Picasso. He constantly badgered the public with new periods in his work, which quickly became old again. Apart from the master of progress that was himself, Picasso loved cars. Hotchkiss Anjou, Hispano Suiza Limousine, Facel Wega Facel II, Mercedes Benz 300 SL—he owned them all, but never drove any of them. He didn't have a driver's licence. The last car he had himself driven around in was a white Lincoln Continental, built in 1963. It was for his love of beautiful cars that Sylvie Fleury devoted a little of her precious time to him. She loves old road cruisers. As the curator of a Swiss motor show, she once exhibited the painter's original Lincoln Continental.

Cars, accessories, high heels, the whole spectrum of fetishized luxury goods, constitute the material for her art. Though "material" makes it sound a little too much like work. The artist does her best to abandon any appearance of effort, simply leaving shopping bags and their contents lying around. Up until now, there have been very few women in the art world with the confidence to do so little. But that isn't the only reason why she is so

179

enviously admired. You might think that Fleury promotes things that are commonly dismissed as vain. But Fleury does not aim to promote anything. She seeks to present things in scenes that get directly to the point. In so doing, she herself plays the stumbling block, offering the object in the manner of a fashion victim, rather than pointing the finger at others. In this role, she accelerates, tires screeching, beyond the bounds of good taste. "You should never forget, when glancing in the rear mirror, to take a careful look ahead as well," she says. She likes very camp, broken things which have gone out of fashion, and celebrates a wrecked car by using nail polish to transform it into a small miracle. Everything she does is a pean to makeup. Trivialized as the darling of the Swiss art scene, Fleury is actually fascinated by how cosmetics can be used as a tool, and hums "when you think, then you only think that you think." Fleury reads Baudelaire as a way of thinking about brain research. But behind this comic figure mask, she likes to push the uber-feminine to its limits, like the time she bought up all the handbags in all the Chanel shops on the French Riviera. It had to be *all* of them, and it could not involve any more effort than simply buying them. The dandy as bimbo poses as a medium. Born to shop. Everything runs through me. This was a search for something other than work, which for her did not mean lost leisure time. Briefly she thought of Patrick Bateman, but immediately forgot him again. She forgot most things. Sometimes she'd remember something. The world is a huge contradiction, and life a full tank. Fleury appeals to our suppressed desires with the same effortless impertinence. She unconditionally says "yes" in a world that seems so beyond hope that it isn't even worth criticizing it. Even displaying on a wall *Égoiste*, the logo for Chanel's men's perfume, is not intended as

rebuke. Fleury's stance is based on an affirmation. The slogan "Yes to All" flickers above everything. A condescending article about one of her first exhibitions was entitled "The Fascination of the Void." Fleury later adopted it as a title for one of her exhibitions. Flirting with nihilism was fun; it sounded a bit like Zen.

Like many people who'd been socialized by punk, Fleury turned her focus to spiritual matters after the revolt subsided. She contemplated the relationship between the masculine and the feminine. Where there wasn't enough yin, she would add some yang. Precisely the passive aspect of Zen can seem kind of dandy. Fleury's flaunted insouciance plays with the risk of not being taken seriously. Secure in her sense of taste, she sticks to her role as an artist bored by moral questions, who wants nothing more than to repair our false reality. Her dogged appeal consists in taking what she wants, irrespective of whether she is allowed it. This seems to contradict the ethics of moderation of this latter-day stoic in her Balenciaga tunic. She leaves untouched things that should be left alone, and is humble enough to alter her environment as little as possible. As a modern proponent of the ancient Greek philosophy that was sympathetic to hedonism, she conceives of man-made artifacts as being part of a greater whole. For that reason, all things in this world deserve to be treated with moderation, which is the opposite of greed. Fleury's canny route out of the Anthropocene amounts to saying *c'est la vie*—don't force it.

The Retired Intern

In a sleepy German small town on the north bank of the Eifel lived a young woman who wanted to find out what life had to offer. Not having been born in a country that had once been full of farmers and was now full of banks, she couldn't just say to herself, "that's just how life is." So instead she asked, "how will my life turn out?" Instead of breathing the pungent smell of cheap clothes in the town's department store, she felt the urge to fly first class and exhibit at Reena Spaulings. That is how Anna landed in New York.

In the photos that have since become famous, the young woman would appear in a little black dress, and gave everyone to understand she was stinking rich. Round her neck she wore a choker, a kind of necklace whose name derives from the English word for "strangulation." In her oversized corrective glasses from Céline, which made her eyes seem almost to disappear, Anna stood out. In the best-known picture, Anna Delvey, which is what she called herself, and Sorokin, which was her real name, is not sweeping off to a gala dinner. She is being led into a courtroom with her hands handcuffed behind her back. It was there that her assault on class society was to be judged.

In her determination not to bore people with predictable answers, Sorokin was a consummate dandy; the first thing she is recorded as saying in court was that she liked being in prison. It was a nice place where you could have a complete break; after all the hullabaloo, it was almost like going to a health resort. Otherwise, being there was like being in New York City: "you just need to know the right people to get the right job." The truck driver's daughter had learned early on how to win powerful and

influential people onto her side. However, she didn't want a job, she wanted money, and lots of it. Delvey did not orchestrate her career on her own. Her friends, who belonged to the highest echelons of society, also played their parts in this piece of theater. Without them, Anna would not have been possible. However, Sorokin was not simply passive, as many expect those of her gender to be; she counterfeited cheques and composed false documents, which would later be certified by, among others, a Swiss bank. She learned how to sound like an asset manager on the telephone, by using a voice changer to make herself seem trustworthy. And yet despite this determination, she eventually ran up against certain limits. In digital surveillance societies, the net is becoming ever more tightly woven. Everyone can google their opponent, and does it quite shamelessly, joining in the general policing of idleness. In this surveillance society, where everyone monitors everyone else, Sorokin only had limited room to manoeuvre. Or did she actually want to get busted in order to disappoint others, as dandies are fond of doing? The first thing she learned was that living among rich people is cheap. You are constantly being invited to things, dinner here, dinner there. Only rarely do you have to pay for anything yourself. Together with her entourage—a film director and a photo editor from *Vanity Fair*—she ended up in a hotel where the suites cost 7,000 dollars a night. This time it was Delvey's turn to pay, but none of her credit cards would work. Her attempts to lay the blame on teething problems with a payment app came to nothing. She was on the point of receiving a loan of over twenty-five million dollars for the Anna Delvey Foundation, which she wanted to use to realize her dream of a three-thousand-square-meter private club for art. The game was over.

The game had begun on a fashion course at Central St Martins in London. Sorokin didn't drop out of it, so much as never seriously begin. It meant waiting too long for the good life. Under the *zugzwang* of boredom, she flew to New York. On the flight she read Thomas Mann's 1954 novel *Confessions of Felix Krull, Confidence Man*. She still wanted to become an artist, and thanks to Mann she learned over these few hours what she needed to do. Why did people need a whole degree for this? After landing in New York, she assumed the identity of a Russian oligarch's heiress. The only evidence of her past life was an Instagram page describing her as a "retired intern." Though it's not entirely clear why, she was effective at convincing people, and no one became suspicious. And in the circles of the very affluent, no one asks the question, what do you do for a living? In that world, there is no need to define yourself by your job.

Her lawyer argued before the court that his client had assumed that adopting this kind of sham existence was normal in New York when trying to realize a great entrepreneurial vision. He ended his plea with the words of Oscar Wilde: "To have done it was nothing, but to make people think one had done it was a triumph." However, in his speech the lawyer had overlooked one thing: while men who make money out of nothing are considered daring, women who do it suffer harsh penalties, since to this day the female practice of alchemy is considered witchcraft.

Delvey, who did not want to work or sleep her way to the top, gave generous tips. Her former "friends" indignantly claimed that she did this with money she hadn't earned, as if they had acquired their inheritances by building roads by the sweat of their brows. Delvey wanted nothing to do with the reality of wealth that results

from the unhygienic mixing of bodily fluids. She was more interested in romance than sex. Exuding self-confidence, she never told people what they wanted to hear, and did what she pleased. Even when arrested, she appeared strangely unconcerned. "Sociopath?" she said, "I see it as a compliment."

Many conmen know no fear. This is what makes their stories so fascinating. While most of us have our heart in our mouth if a card reader takes more than a couple of seconds to approve our payment, Delvey was still living in expensive hotels when she was already a few hundred thousand dollars in debt—it was almost as if the greater her debts, the higher the prices of the hotels in which she stayed. In Germany she had once heard the phrase: "If you owe five thousand euros, you have a problem, but if you owe five hundred thousand euros, then your bank has a problem." Did she want to have a problem? Definitely not.

Conmen are reluctant to accept that something is the case. They are more interested in what might be the case. The German term *hochstapeln,* to swindle, derives from the world *betteln,* to beg, and only acquired its present meaning with the emergence of bourgeois society in the nineteenth century. While the bourgeois worked their way up the social ladder with earnest toil, preferring to remain modestly mediocre, conmen grabbed at passing opportunities. Their upward mobility is dependent upon the expectations of the social group they aspire to join. A crucial key to their success is a love of detail, which they employ to make their deception convincing. They obscure their original identity by taking great pains to conform to expectations about their assumed one. Both conmen and dandies have in common the fact that they reject the identities they've been given. However, not all dandies

are conmen. And while dandies enjoy disappointing others, if the conmen's curtain of deceit ever falls it spells defeat. Once exposed, their whole existence is revealed as an imposture. Sorokin, however, managed to overturn this rule. After the plot had played out, Netflix bought from her the rights to Anna Delvey. The advance for the fictional character alone was enough to settle unpaid bills that were very real.

After being released from Rikers Island, Anna took a taxi to the Nomad Hotel on Fifth Avenue. There, as if wanting to confirm prejudices, she ordered caviar. While the German Russian enjoyed her beluga, she watched people passing on the street outside, and thought of Felix Krull. Mann's portrait sketch of an artist declares that for any fiction to be convincing, it needs a carefully judged admixture of truth.

Looking Good as Things Fall Apart

Anna sat on the other side of the large glass and slurped a *fine de claire*. Her hair was dishevelled and she was wearing a camouflage jacket along with something from Valentino. Our conversation turned to the question of how the mosaic pieces of class, gender, skin color, religion, sexual orientation, profession, political stance, and character could be assembled into a whole. How are we supposed to be identical with ourselves, when our selves consist of a thousand different pieces? To be honest, I didn't much like Anna's taste, but you could rely on her to tell you what she thought. Everything she said implied a counter-statement, which took you by surprise, like a piercing breeze.

Though there were some things about her behavior that were dandy-like, there were also clear differences. Anna wanted to become someone and set herself unrealistic goals, something dandies rarely do. In a sense, it is a genuine paradox that many dandies who became colorful characters and left behind lasting impressions would actually have preferred to disappear altogether. Though without ambition, they proved highly influential. What was impressive about them could not be measured by common criteria; they did not conform to any established order and weren't interested in pleasing anyone. In a world where we're constantly forced to be nice to each other, this form of dissent struck me as particularly attractive, and I thought: there are quite a few people who ought to be dandies. I shut my eyes and imagined a world where, instead of writing multiple-page CVs to promote themselves and how hard they work, people would just write their names and what they'd like to do. I'd no longer be surrounded by people at parties telling

me about their jobs and how successful they are. No one would feel the need to sell themselves, since everyone would have long since left behind the world of work. Instead of always centering round their interlocutors, conversations would take wild and unexpected turns. The term "asceticism" would acquire a renewed meaning, and would be accompanied by the understanding that any ambition to bring something new into the world should be treated with great circumspection. Restraint would be the new virtue. And if anything new did in fact emerge, it would seem bolder and crazier. None of it would ever be about money, since money would no longer matter; nor would it be about doing something that looks good on your CV. "CV" would have become an abbreviation of "caviar and vacation"; everyone would do things out of commitment and pleasure. Sometimes it would take a small eternity before anything emerged. Movements would limp past, and for them to hang about would be considered downright pretentious. Even the word "pretentious" would in the future have lost all the negative connotations it has in class society, where it is used to vilify the upwardly mobile. The word would return to its original meaning of a shield I hold in front of myself to keep a proper distance between myself and others, so as not to burden them with my authenticity. In this world made by and for dandies, no one would take themselves too seriously. Everyone would be constantly playing a role, while the machines did all the work. Rather than inflicting their identity on others, human beings would be artificial, charming, and funny. An age of somnolent brashness would reign. Indeed, as more and more people aspired to become dandies, strange manners of speaking and thinking would become ubiquitous. Nowhere would you hear people pointedly disparaging

others behind their backs, or brazenly regurgitating received wisdoms. There would be few who held exaggeratedly high opinions of themselves, and fewer still who dangerously combined these with inferiority complexes. Tedious, second-hand opinions would be considered distasteful. Trying to conform to other people's expectations would be considered unfashionable. Instead of always trying to do what's considered right, everyone would make an effort to surprise others, as a way of avoiding the boredom of predictability. In this world, subject and identity, those driving forces of capitalist competition, would stand idle. Instead of telling you who they think they are, people would rather talk about the form and shape of things—and what they had to say would never be trite or hackneyed. A love of surfaces and of open-endedness would make entire worlds accessible, without nailing down meanings. Where once the thought police of power, with its meanings and categorical assertions, had prevailed, there would now be a dance of shimmering impulses. The age of a last generation's wandering gazes would arrive, a generation that would turn its melancholy into a celebration.

Floating lightly above the ground, I'd take my leave of those who assumed me to be one thing or another. A dandy doesn't need an identity by which to compare herself with others; amazed by the world, she prefers to watch it. Asleep in front of the mirror, I was reflecting on how vivid this existence could feel, when a shot rang out. This had become normal in Zurich, and hardly anyone batted an eyelid. In this city of repressed feelings, whose chill I'd often felt, the breakdown of order was refreshing. I huddled against the cold in my cashmere blanket, and considered who or what I was. A man and a woman, between 165 and 181 centimeters tall, raw-boned and overweight,

pale and glowing, unemployed and capitalist, communist and secretly reactionary, perverse and actually rather staid. And as well as all that I'm a dandy, as a way of protecting myself from everything that would wear me down.

While droplets of this false world were running off my tense skin in iridescent rivulets, everything suddenly started happening very quickly. Over the winter, Europe was already clearly in chaos. Then things started happening in quick succession. Within a few months, many European countries had transformed themselves into post-Fascist states on the Italian model—either that, or they had no one in charge of them any more. Needless to say, it wasn't long before the EU broke up. A united Europe and neoliberalism now existed only in history books. Following its deindustrialization, Germany rapidly descended into poverty, and had now become ungovernable. What had been described just a couple of years before as a skilled labor shortage and an energy crisis was now out-and-out anarchy. Since there were no longer any police or border guards, starving Germans would cross the border to loot Swiss supermarkets. Even Switzerland had long since lost its reputation as a paradise of peace and security. The high-tech companies and the luxury hotel industry had long since emigrated to Asia, where there were at least still enough nuclear reactors to ice the mountains with artificial snow. Thanks to a cheap Swiss franc, a sex industry catering to every taste quickly emerged in the country's former ski resorts. Whether it was St. Moritz, Saas-Fee or Gstaad, prostitution boomed amid the chalets and alpine meadows. Unlike the Germans, we Swiss Confederates held on to our place in the world market, found another way of doing what we did best, and went on living the good life. To this day, I still dine every Sunday at that institution of Zurich gastronomy,

the Kronenhalle. It's not just the food I like, but the attentiveness of the waiters and the interior, where everything is both opulent and unassuming. Who eats biscuits, when you can have cake? Only people with weak stomachs. Everything here tastes good, marking it as an establishment that caters specifically to the dandy; as Valéry put it, "taste is made of a thousand distastes." Though the term "taste" may be out of favor, a taboo criterion in the art world, the obvious value judgements which are being promoted as its "democratic" substitutes are scarcely more than instruments of a surveillance society. Why eat at places where the soup makes you retch? At the Kronenhalle it tastes good, and as I savor it I ask myself what, for the unknown future, I'd like to salvage from this dying Europe. I imagine a spaceship which has incorporated the Kronenhalle as its dining room. Since everything has had to be done very quickly, there are still cables dangling everywhere, and the old woodwork has had to be converted to accommodate the new technology. The Kronenhalle now looks like a techno shack from *Mad Max 3,* where Tina Turner is about to show up any minute. I sit there expectantly at a long table with a group of people who are close to my heart, as well several others who appear in this book. As we fish the strips of pastry out of our bouillon, a very well-known Zurich family sits down at the table next to us. I think: they haven't been invited, but they've been regular guests at this establishment for generations. Should we, at this moment of apocalypse, throw out these messengers of a past age? Their three children look flawless, as if they'd been cloned. As is the custom in this little country, they still put on an outward show of humility, solemnly watching the waiter prepare the *tartare de boeuf* in a wooden bowl as if it were a charming puppet show. With a gesture I give the waiter to under-

stand that they can come with us. At my table are sitting Hannes, Helene, Marie, Bateman, and several other people. The atmosphere is convivial, and everyone is dressed up to the nines. Together we sing "Every Collapse is a Transition." Towards the back of the room, I can make out Beau, Raymond, Hanne, Tabea, Stephan, and all the others. Merlin, who isn't joining in with the singing, is biting off a button. At this moment, the waiter places the filet Robespierre on the hot tray. Daisy, the cutest of chihuahuas, watches fixedly, as if the man in the tailcoat were going to stick a burning torch down his throat. Then a voice says, it's ready, and her teeth sink into the lukewarm meat. Time in the room now seems to stand still. The waiters stop deftly lifting covers from silver dishes. Apart from Daisy's unselfconscious chomping, there's not a sound to be heard. I think: there are Soutines, Chagalls, and Picassos hanging on the wood-panelled walls; we can still throw them out the window when we're over Italy. I love art, but doesn't that mean an eternal farewell? The last things I'd get rid of would be the curtains, which cast a soft, chalky light over everything, and perfect the sense that in this place you are disburdened of everything. Zurich is now sinking into chaos beneath us, but you can't feel any of it in here. As the restaurant slowly tears itself from the ground, I think: I hope it all goes all right. Although the waiters have firmly locked the doors, every now and then something still falls to the ground. The cloned children are wailing because no one has told them that everything's going to get better now. As Hannes holds Daisy on his lap, Patrick, unable to contain his excitement for the world to come, pukes over her filet Robespierre, leaving her unconsolable. Through the cracks in the floor I watch a mob of greedy investment bankers fighting over the silver candlesticks that

fell out of the windows when we lifted off. I like the present moment. It is better than any past one. Soon we are gliding over the Alps. Many people will say that this is a form of escapism. But for us it is a long flight out of a present that is destroying itself, in which, in a little Noah's Ark, we travel towards the new world carrying a handful of ideas that can be called dandyism or art, depending on how we're feeling.

Part two—the arrival—will be coming out once we've landed.

Our sincere thanks to:

Hannes Loichinger in particular for his unremitting
motivation to get to the point, the many excellent
suggestions in editing the manuscript, and the friendship
without which this book would not exist.
Julia Künzi of the Kunsthalle Bern for the many
different ways in which she supported the organization
of the exhibition and for her persistence in reading the
very first and very last versions.
The team of the Kunsthalle Bern and in particular
Iris Frauchiger, without whom it would not have been
possible to realize such a complex exhibition.
Lina Grumm and Annette Lux from HIT for the
wonderful design of the invitation card, the poster, and
especially this book.
Nathaniel McBride for the sensitive approach to our
view of the dandy and the careful translation into English.
Karin Prätorius for the patient proofreading and for
pointing out where we have exaggerated.
Stephan Dillemuth for his intensive readings, the many
pertinent questions and suggestions.
Michael Krebber for unwittingly giving the impetus,
looking at the text with a soberly euphoric eye and
insisting on accuracy.
Daniel Buchholz for shared passion, generous support
of the exhibition, numerous references to Raymond
Roussel, and close reading of the manuscript.
Hanna Mittelstädt for her rigorous eye and the wealth
of her experience.
Judith Düsberg for organizing and grounding the
text in its draft form.
Kévin Blinderman, Pierre-Alexandre Mateos, and
Charles Teyssou for their staging of the exhibition

in the exhibition, their wonderful patience for our questions about Jacques de Bascher and the invitation to write the scandal text.

Ursula Böckler for making her photographs available and for the conversations about Martin Kippenberger.

John Kelsey for the shared love of detail.

Alexander Schröder for the loans from his mother's dark hallway and his infectious enthusiasm.

Gunnar Reski for his upbeat ennui and insistence on the right questions.

Maria Gilissen's invitation to the family séance with wardrobe changes and her suggestions about Marcel Broodthaers's relationship with *Monsieur Teste*.

Ingrid Wiener for reading the passages she witnessed.

Volker Lang and Mariella Mosler for the exchange about stanley brouwn.

James Gregory Atkinson for the rigorous reading of the passages on *Black Dandyism*.

Christian Nagel for many things, and especially for pointing out that Kippenberger did not finish reading Diderot.

Nicolas Tammens for the radio talk and the numerous references.

Philip Mann for the stimulating encounter and for the encouragement to take our time when writing about the dandy.

Henning Bohl and Raphaela Vogel for their accounts of dandyism at the Städelschule.

Andrea Fraser for precisely answering our detailed questions.

Ariane Müller for persistently referencing the courtesan.

Mathieu Malouf for talking about himself as a dandy at Woodstock.

Harald Thys for the conversation about fear.
Gunter Sachs for his clever stories.
Merlin Carpenter for the gruff refusal to participate in
the exhibition and all the reflections this triggered in us.
Laszlo Glozer for the hours in his kitchen and the truth
about the moths in Beuys's fur coat.
Christopher Müller for the videos whose titles cannot
be mentioned here.
Marie Angeletti for her espionage at the Villa Jako
and the translation of the chapter on stanley brouwn
into French.
Peter Currie and Robert Snowden for their precise
answers to all our questions about Lutz Bacher.
Luc Haenen for the conversation about Lutz Bacher.
Jochen Weber for secret reasons.
Jorinde Reznikoff for the crystal-clear narration
in the Virginia Woolf broadcast.
Nicolas Schneider for the internationalization
of the inventory of Jacques de Bascher.

The Hotel Bellevue Palace for its saving existence.
The Hotel Danieli for the cheap room.
The Hotel Schweizerhof for its soap and marrowbone.
The Brasserie am Bärengraben, the Plat du Jour, the
Vienna, the Kronenhalle, and the Ritz
for their hospitality.

The Kunsthalle Bern for its stoic forbearance.
The city of Bern for its tolerance and generous financial
support.
Switzerland for the downfall.

Bibliography

Anonymous. *Conspiracist Manifesto*. Translated
by Robert Hurley. Los Angeles: Semiotext(e), 2023.

Agamben, Giorgio. *The Man Without Content*.
Translated by Georgia Albert. Stanford: Stanford
University Press, 1999.

Agamben, Giorgio. *Taste*. Translated by Cooper Francis.
New York: Seagull Books, 2017.

Althusser, Louis. *For Marx*. Translated by Ben Brewster.
London: Verso, 2006.

Améry, Jean. *On Suicide: A Discourse on Voluntary
Death*. Translated by John D. Barlow. Bloomington:
Indiana University Press 1999.

Anger, Kenneth. *Hollywood Babylon*. London:
Arrow Books, 1986.

Artaud, Antonin. "To End God's Judgement."
Translated by Victor Corti. *The Tulane Drama Review*,
vol. 29, no. 3 (Spring 1965): 56–98.

Aurel, Marc. *Meditations*. Translated by Gregory Hays.
New York: Random House, 2003.

Balzac, Honoré de. *Treatise on Elegant Living*.
Translated by Napoleon Jeffries. Cambridge, MA:
Wakefield Press, 2010.

Balzac, Honoré de. *Die Kunst, seine Schulden zu zahlen*.
Translated by E. Fred. Insel Verlag: Frankfurt am Main
2016.

Balzac, Honoré de. *Lost Souls*. Translated by Raymond
N. MacKenzie. Minneapolis: University of Minnesota
Press, 2020.

Barbey d'Aurevilly, Jules. *Dandyism*. Translated by
Douglas Ainslie. New York: PAJ Publications, 1988.

Barthes, Roland. "The Death of the Author."
In Roland Barthes. *The Rustle of Language.* Translated
by Richard Howard, 49–55. Berkeley/Los Angeles:
University of California Press, 1989.

Baruchello, Gianfranco and Henry Martin. *Why
Duchamp: An Essay on Aesthetic Impact.* New Paltz:
McPherson, 1985.

Baudelaire, Charles. *The Painter of Modern Life:
Modernity is The Transient, The Fleeting, The
Contingent.* Translated by P. E. Charvet. London:
Penguin, 2010.

Baudelaire, Charles. *The Flowers of Evil.* Translated by
James N. McGowan. Oxford: Oxford University Press,
1998.

Bauer, Wolfgang. *Change and Other Plays.* Translated
by Martin Esslin. New York: Hill and Wang, 1973.

Baum, Stella. "Fettiges Rinnsal an der Wand."
Der Spiegel, vol. 33, no. 45 (November 5, 1979): 261.

Bayer, Konrad. "nobody helps me." In *Austrian
Poetry Today / Österreichische Lyrik heute*, edited and
translated by Milne Holton and Herbert Kuhner,
131–33. New York: Schocken Books, 1985.

Becker-Ho, Alice and Guy Debord. *A Game of War.*
Translated by Donald Nicholson-Smith. London:
Atlas Press, 2007.

Bender, Annika. *Diversity United.* Hamburg:
Materialverlag, 2021.

Benjamin, Walter. *Charles Baudelaire: A Lyric Poet in
the Era of High Capitalism.* Translated by Harry Zohn.
London: NLB, 1973.

Benjamin, Walter. "The Destructive Character."
Translated by Edmund Jephcott. In Walter Benjamin.

Reflections: Essays, Aphorisms, Autobiographical Writings, edited by Peter Demetz, 301–03. New York: Harcourt Brace Jovanovich, 1978.

Berger, Verena (ed.). Hanne Darboven. *Unbändig.* Ostfildern: Hatje Cantz, 2015.

Bernadette Corporation. *Reena Spaulings.* New York/Los Angeles: Semiotext(e), 2004.

Bernstein, Michèle. *All the King's Horses.* Translated by John Kelsey. Los Angeles: Semiotext(e), 2008.

Bernstein, Michèle. *The Night*, edited by Everyone Agrees. Translated by Clodagh Kinsella. London: Book Works, 2013.

Bieri, Martin. "Black Bern." In Vincent O. Carter. *Meine weisse Stadt und ich: Das Bernbuch*, 422–34. Translated by pociao and Roberto de Hollanda. Zürich: Limmat Verlag, 2021.

Bloy, Léon. *On Huysmans' Tomb: Critical Reviews of J.-K. Huysmans and À Rebours, En Rade, and Là-Bas.* Translated by Richard Robinson. Portland: Sunny Lou Publishing, 2009.

Blumenschein, Tabea. *Das Kreuz der Erfahrung.* Kassel: Martin Schmitz, 1991.

Böckler, Ursula. *Martin Kippenberger's "Magical Misery Tour."* Berlin: Bierke Verlag, 2016.

Bonin, Cosima von and Michael Krebber. "Eine dicke Spinne: Martin Kippenberger (1953–1997)." *Spex*, no. 5 (May 1997): 58.

Bonin, Cosima von et al. "Der Vampir von Köln agiert im Loop." *Spex*, no. 337 (March/April 2012): 66–73.

Bourriaud, Nicolas. *The Exform.* Translated by Erik Butler. London/New York: Verso 2016.

Braun, Christina von. "Der Schwindel mit dem Schwindel." In *Archipele des Imaginären*, edited by Jörg Huber et al., 195–207. Zürich: Edition Voldemeer and Wien/New York: Springer, 2009.

Bronfen, Elisabeth and Barbara Straumann. *Diva. Eine Geschichte der Bewunderung.* München: Schirmer Mosel, 2002.

Busch, Kathrin. *Passivität.* Hamburg: Textem, 2012.

Cabane, Pierre. *Dialogues with Marcel Duchamp.* Translated by Ron Padgett. London: Da Capo Press, 1987.

Caillois, Roger. *Man, Play, and Games.* Translated by Meyer Barash. Urbana and Chicago: University of Illinois Press, 2001.

Carpenter, Merlin. "The Sound of Bamboo." In Michael Krebber. *Apothekerman*, 28–32. Exhibition catalogue: Kunstverein Braunschweig / Städtische Galerie Wolfsburg. Cologne: Walther König, 2000.

Carré, John le. *Smiley's People.* London: Penguin, 2020.

Carroll, Lewis. *Alice's Adventures in Wonderland and Through the Looking-Glass.* Oxford: Oxford University Press, 2009.

Carrouges, Michel. *Les machines célibataires.* Paris: Arcanes, 1954.

Carter, Vincent O. *The Bern Book: A Record of a Voyage of the Mind.* New York: John Day Co., 1973.

Cauty, Jimmy and Bill Drummond. *The Manual (How to Have a Number One the Easy Way).* London: ellipsis, 1999.

Certeau, Michel de. *The Practice of Everyday Life.* Translated by Steven Randall. Berkeley/Los Angeles/London: University of California Press, 1988.

Chamanyou, Grégoire. *The Ungovernable Society: A Genealogy of Authoritarian Liberalism*. Translated by Andrew Brown. Cambridge: Polity Press, 2021.

Clausewitz, Carl von. *On War*. Translated by Michael Howard and Peter Paret. Princeton: Princeton University Press, 1989.

Conzen, Ina (ed.). *Hanne Darboven: Kinder dieser Welt*. Exhibition catalogue, Stuttgart: Staatsgalerie. Stuttgart: Hatje Cantz, 1997.

Cook, Roger. "Democratic Dandyism: Aesthetics and the Political Cultivation of Sens." *Theory & Event*, vol. 13, no. 4 (2010): n. p.

Crowley, Aleister. *Gilles de Rais: The Banned Lecture*. München: Belleville, 2010.

Danson, Lawrence. *Max Beerbohm and The Mirror of the Past*. Princeton, NJ: Princeton University Library, 1982.

Debord, Guy. *Considerations on the Assassination of Gérard Lebovici*. Translated by Robert Greene. Los Angeles: TamTam Books, 2001.

Debord, Guy. *Panegyric*. Vol. 1 & 2. Translated by James Brook and John McHale. London/New York: Verso, 2009.

Deleuze, Gilles and Felix Guattari. *Anti-Oedipus: Capitalism and Schizophrenia*. Translated by Robert Hurley, Mark Seem, and Helen R. Lane. Minneapolis: University of Minnesota Press, 2000.

Deleuze, Gilles. "Raymond Roussel, or the Abhorrent Vacuum." Translated by Michael Taormina. In Gilles Deleuze. *Desert Islands and Other Texts 1953–1974*, edited by David Lapoujade, 72–73. Los Angeles/New York: Semiotext(e), 2004.

Deleuze, Gilles. "Coldness and Cruelty." Translated by
Jean McNeil. In *Masochism*, 9–138. New York: Zone
Books, 2006.

Delmont, Werner von. *Corporate Rokoko and the End of
the Civic Project*. Copenhagen: Pork Salad Press, 2002.

Derrida, Jacques. *Specters of Marx*. Translated by
Peggy Kamuf. New York/London: Routledge, 1994.

Descombes, Vincent. *Puzzling Identities*. Translated
by Stephen Adam Schwartz. Cambridge, MA: Harvard
University Press, 2016.

Diderot, Denis. *The Paradox of Acting*. Translated by
Walter Herries Pollock. London: Chatto & Windus, 1883.

Diderot, Denis. *Rameau's Nephew and D'Alembert's
Dream*. Translated by Leonard Tancock. London:
Penguin Books, 1976.

Diederichsen, Diedrich. "My Material Is the Parrot:
A Conversation with Michael Krebber." Translated
by Jeanne Haunschild. In *Michael Krebber: Artist—
Painter*, 2–23. Exhibition catalogue. Graz: Edition
Forum Stadtpark, 1991.

Diederichsen, Diedrich. "Roundtable Excerpts."
In *Make Your Own Life: Artists In & Out of Cologne*,
edited by Bennett Simpson, 34–37. Exhibition catalogue.
Philadelphia: Institute of Contemporary Art, 2006.

Diederichsen, Diedrich. "Nachwort". In *Martin
Kippenberger: Wie es wirklich war. Am Beispiel. Lyrik
und Prosa*, edited by Diedrich Diederichsen, 343–60.
Frankfurt am Main: Suhrkamp 2007.

Dillemuth, Stephan. "What's your name, Bohemia?"
Translated by Gerrit Jackson. *Texte zur Kunst*, no. 97
(March 2015): 126–32.

Drake, Alicia. *The Beautiful Fall: Fashion, Genius, and
Glorious Excess in 1970s Paris*. London: Bloomsbury,
2006.

Draxler, Helmut. "Or: The Last Bourgeois." Translated by Nicolas Grindell. In *Michael Krebber*, 8–10. Exhibition catalogue, Vienna: Secession. Cologne: Walther König, 2005.

Draxler, Helmut and Michael Krebber. "Taste Rules the Genes: An E-mail Conversation Between Helmut Draxler and Michael Krebber." Translated by Gerrit Jackson. *Texte zur Kunst*, no. 75 (September 2009): 113–16.

Duchamp, Marcel and Vitali Halberstadt. *L'Opposition et les cases conjuguées sont réconciliées par M. Duchamp & V. Halberstadt*. Paris-Bruxelles: Éditions de L'Échiquier, 1932.

Duras, Marguerite. *Practicalities*. Translated by Barbara Bray. New York: Grove Weidenfeld, 1992.

Ellis, Bret Easton. *American Psycho*. New York: Random House, 1991.

Ellis, Bret Easton. *White*. New York: Penguin Random House, 2019.

Ellison, Ralph. *Invisible Man*. New York: Random House, 1952.

Erbe, Günter. *Der moderne Dandy*. Cologne/Weimar/Vienna: Böhlau, 2017.

Fanon, Frantz. *Black Skin, White Masks*. Translated by Richard Philcox. London: Penguin Books, 2021.

Faust, Wolfgang Max. "Der Künstler als exemplarischer Alkoholiker." *Wolkenkratzer Art Journal*, no. 3 (March 1989): 20–21.

Faust, Wolfgang Max. *Dies alles gibt es also: Alltag, Kunst, Aids*. Stuttgart: Hatje Cantz 1993.

Federici, Silvia. *Witches, Witch-Hunting, and Women*. Oakland, PM Press, 2018.

Feldman, Jessica Rosalind. *Gender On the Divide: The Dandy in Modernist Literature*. Ithaca/London: Cornell University Press, 1993.

Filipovic, Elena. *David Hammons. Bliz-aard Ball Sale*. London: Afterall Books, 2017.

Fisher, Mark. "Touchscreen Capture." *Noon. An Annual Journal of Visual Culture and Contemporary Art*, no. 6 (2016): 12–27.

Fleury, Sylvie and Samual Gross. "Interview with Sylvie Fleury." In *Sylvie Fleury*, edited by Samuel Gross, 65–73. Exhibition catalogue, Geneva: Société des Arts. Zurich: jrp|ringier, 2015.

Földényi, László F. *Melancholy*. Translated by Tim Wilkinson. New Haven/London: Yale University Press, 2016.

Ford, Simon. *Situationist International: A User's Guide*. London: Black Dog Publishing, 2004.

Foucault, Michel. "What is Enlightenment?" Translated by Catherine Porter. In *The Foucault Reader*, edited by Paul Rabinow, 32–50. New York: Pantheon Books, 1984.

Foucault, Michel. *The Use of Pleasure*. Translated by Robert Hurley. New York: Vintage Books, 1990.

Foucault, Michel. "The Life of Infamous Men." Translated by Paul Foss and Meaghan Morris. In Michel Foucault. *Power, Truth, Strategy*, edited by Meaghan Morris and Paul Patton, 67–91. Sydney: Feral Publications, 2006.

Foucault, Michel. *Death and the Labyrinth: The World of Raymond Roussel*. Translated by Charles Ruas. London/New York: Continuum, 2007.

Fox, Dan. *Pretentiousness: Why It Matters*. Minneapolis: Coffee House Press, 2016.

Fusco, Coco and Christian Haye. "Wreaking Havoc on the Signified." *frieze*, no. 22 (May/June 1995): 34–41.

Garelick, Rhonda K. *Rising Star: Dandyism, Gender, and Performance in the Fin de Siècle*. Princeton: Princeton University Press, 1998.

Gates, Jr., Henry Louis. *The Signifying Monkey: A Theory of African-American Literary Criticism*. New York/Oxford: Oxford University Press, 2014.

Geer, Nadja. *Sophistication: Zwischen Denkstil und Pose*. Göttingen: V&R unipress, 2012.

Gentili, Dario. *The Age of Precarity: Endless Crisis As an Art of Government*. Translated by Stefania Porcelli. London: Verso, 2021.

Gnüg, Hiltrud. *Kult der Kälte: Der klassische Dandy im Spiegel der Weltliteratur*. Stuttgart: Metzler, 1988.

Goncharov, Ivan. *Oblomov*. Translated by C. J. Hogarth. New York: The Macmillan Company, 1915.

Gracián, Baltasar. *The Art of Worldly Wisdom: A Pocket Oracle*. Translated by Christopher Maurer. New York: Doubleday, 1992.

Gracián, Baltasar. *A Pocket Mirror for Heroes*. Translated by Christopher Maurer. New York: Doubleday, 1996.

Graw, Isabelle. "I Love Kippenberger: Über die aktuelle Ausstellung von Andrea Fraser in der Galerie Nagel, Köln." *Texte zur Kunst*, no. 43 (September 2001): 156–60.

Graw, Isabelle. "Rivalität der Schillernden." *Die Tageszeitung,* January 15, 2007. taz.de/!329264/.

Graw, Isabelle. "The Poet's Seduction. Six theses on Marcel Broodthaers's contemporary relevance." Translated by Gerrit Jackson. *Texte zur Kunst*, no. 103 (September 2016): 48–72.

Gruenter, Rainer. *Vom Elend des Schönen. Studien zur Literatur und Kunst*, edited by Heinke Wunderlich. Munich/Vienna: Hanser, 1988.

Gustorf, Oliver Körner von. "Frau ohne Eigenschaften." *Die Tageszeitung*, September 8, 2020. taz.de/Austellung-ueber-Tabea-Blumenschein/!5708256/.

Hainley, Bruce. "Erase and Rewind." *frieze*, no. 53 (June–August 2000): 82–87.

Hammons, David. *Blues and The Abstract Truth*. Bern: Kunsthalle Bern, 1997.

Hegel, Georg Wilhelm Friedrich. *The Phenomenology of Spirit*. Translated by Terry Pinkard. Cambridge: Cambridge University Press, 2018.

Herbert, Martin. *Tell Them I Said No*. Berlin: Sternberg Press, 2016.

Hermes, Manfred. "The Reverse Sublime, Doubly Inverted." Translated by Carrie Roseland. In *Michael Krebber: The Living Wedge*, vol. 2, edited by Valérie Knoll and João Ribas, 81–90. Exhibition catalogue, Bern/Porto: Kunsthalle Bern/Museu de Arte Contemporânea. London: Koenig Books, 2017.

Hettlage, Robert. *Der Dandy und seine Verwandten: Elegante Flaneure, vergnügte Provokateure, traurige Zeitdiagnostiker*. Wiesbaden: Springer, 2014.

Heubach, Friedrich Wolfram. *le dandysme*. Hamburg: Textem, 2017.

Heyden-Rynsch, Verena von der. "Nachbemerkung der Herausgeberin." In *Riten der Selbstauflösung*, edited by Verena von der Heyden-Rynsch, 325–26. München: Matthes & Seitz Verlag, 1982.

Highsmith, Patricia. *The Talented Mr Ripley*. London: Vintage Books, 1999.

Highsmith, Patricia. *Ripley Under Ground*. London: Vintage Books, 1999.

Highsmith, Patricia. *The Boy Who Followed Ripley*. New York/London: W. W. Norton & Company, 2008.

Hörner, Ferdinand. *Die Behauptung des Dandys: Eine Archäologie.* Bielefeld: transcript, 2008.

Huizinga, Johan. *Homo Ludens: A Study of the Play-Element in Culture.* Translated by R. F. C. Hull. London: Routledge & Kegan Paul, 1949.

Huysmans, Joris-Karl. *The Damned (Là-Bas).* Translated by Terry Hale. London: Penguin Books, 2001.

Huysmans, Joris-Karl. *Against Nature (A Rebours).* Translated by Robert Baldick. London: Penguin Books, 2003.

Huysmans, Joris-Karl. "In Hamburg und Lübeck." Translated by Gernot Krämer. *Sinn und Form*, no. 4 (July/August 2019): 485–93.

Isherwood, Christopher. *The World in the Evening.* London: University of Minnesota Press, 1999.

Jesse, William. *The Life of George Brummel.* London: Saunders & Otley, 1844.

Kelsey, John. "Stop Painting Painting." *Artforum*, vol. 244, no. 2 (October 2005): 222–25.

Kelsey, John. "High Lines (For Sick Bees)." In *Whitney Biennial 2012*, edited by Elisabeth Sussman and Jay Sanders, 26–27. Exhibition catalogue. New York: Whitney Museum of American Art, 2012.

Kelsey, John. "Refresh=Death." In *Stop Painting*, edited by Peter Fischli, 112–15. Venedig/Mailand: Fondazione Prada, 2020.

Kippenberger, Martin and Matthias Schaufler. *William Holden Company: The Hot Tour.* Berlin: Wewerka & Weiss Galerie, 1991.

Kippenberger, Martin. "1984. Wie es wirklich war am Beispiel Knokke." In *Martin Kippenberger: Wie es wirklich war. Am Beispiel. Lyrik und Prosa*, edited by Diedrich Diederichsen, 73–113. Frankfurt am Main: Suhrkamp, 2007.

Kippenberger, Martin. "Café Central: Skizze zum Entwurf einer Romanfigur." In *Martin Kippenberger: Wie es wirklich war. Am Beispiel. Lyrik und Prosa*, edited by Diedrich Diederichsen, 155–334. Frankfurt am Main: Suhrkamp, 2007.

Kippenberger, Susanne. *Kippenberger: The Artist and His Families*. Translated by Damion Searls. Atlanta/New York: J&L Books, 2013.

Koether, Jutta. "The Nonchalance of Continuous Tense-ness." Translated by Catherine Schelbert. *Parkett*, no. 58 (2000): 104–8.

Koether, Jutta. "In Memoriam: Karl Lagerfeld (1933–2019). An Interview with Jutta Koether." Translated by Matthew Scown. *Texte zur Kunst*, March 3, 2019, textezurkunst.de/en/articles/memoriam-karl-lagerfeld-1933-2019/.

Kracauer, Siegfried. *Jacques Offenbach and the Paris of His Time*. Translated by Gwenda David and Eric Mosbacher. New York: Zone Books, 2002.

Krauss, Rosalind. *A Voyage On the North Sea*. Zürich: Diaphanes, 2008.

Krebber, Michael. *Außerirdische Zwitterwesen – Alien Hybrid Creatures*. Cologne: Walther König, 2005.

Krebber, Michael (ed.). *Ical Krbbr Prodly Prsnts Gart Jas, Jon Klsy, Josf Stra*. Exhibition catalogue, Frankfurt: Portikus. Cologne: Walther König, 2007.

Kreuzer, Helmut. *Die Boheme. Analyse und Dokumentation der intellektuellen Subkultur vom 19. Jahrhundert bis zur Gegenwart*. Stuttgart: Metzler, 2000.

Kukuljevic, Alexi. *Liquidation World: On the Art of Living Absently.* Cambridge, MA: MIT Press, 2017.

Laclos, Choderlos de. *Dangerous Liaisons.* Translated by Helen Constantine. London: Penguin Books, 2007.
Lafargue, Paul. *The Right to be Lazy and Other Writings.* Translated by Alex Andriesse. New York: NYRB, 2022.
Lazzarato, Maurizio. *Marcel Duchamp and the Refusal of Work.* Translated by Joshua David Jordan. Los Angeles: Semiotext(e), 2014.
Lecci, Leo. *Marcel Duchamp: widersprüchlich & widersprochen*, edited by Walter Vitt. Translated by Rachela Abbate. Deinigen: Druckerei & Verlag Steinmeier, 2014.
Lottmann, Joachim. *Mai, Juni, Juli.* Köln: Kiepenheuer & Witsch, 2010.
Lyotard, Jean-François. *The Postmodern Explained to Children: Correspondence 1982–1985.* Translated by Julian Pefanis and Morgan Thomas. Sydney: Power Publications, 1992.

Mann, Otto. *Der Dandy. Ein Kulturproblem der Moderne.* Berlin: Julius Springer, 1925.
Mann, Philip. *The Dandy at Dusk: Taste and Melancholy in the Twentieth Century.* London: Head of Zeus, 2017.
Mann, Thomas. *Confessions of Felix Krull, Confidence Man.* Translated by Denver Lindley. New York: Vintage International, 1992.
Mallarmé, Stéphane. "A Dice Throw At Any Time Never Will Abolish Chance." Translated by E. H. and A. M. Blackmore. In Stéphane Mallarmé. *Collected Poems and Other Verse*, 161–81. Oxford: Oxford University Press, 2006.

Marcus, Greil. *Lipstick Traces: A Secret History of the Twentieth Century*. London: Faber and Faber, 2011.

Margueritte, Victor. *The Bachelor Girl*. Translated by Hugh Burnaby. New York: Alfred A. Knopf, 1923.

Meadows, Dennis et al. *The Limits to Growth: A Report for the Club of Rome's Project on the Predicament of Mankind*. New York: Universe Books, 1972.

Mesrine, Jacques. *The Death Instinct*. Translated by Catherine Texier and Robert Greene. USA: Tam Tam Books, 2014.

Miller, John. "The Weather is Here: Wish You Were Beautiful." *Artforum*, vol. 228, no. 9 (May 1990): 152–59.

Miller, Monica L. *Slaves to Fashion: Black Dandyism and the Styling of Black Diasporic Identity*, Durham/London: Duke University Press, 2009.

Miroglio, Francesco. *The Bizarre World of Raymond Roussel and Marcel Duchamp's* Large Glass, edited by Gerhard Graulich and Kornelia Röder. Schwerin: Duchamp Forschungszentrum, 2020.

Musil, Robert. *The Man Without Qualities*. Translated by Sophie Wilkins. London: Picador, 2017.

O'Doherty, Brian. *Inside the White Cube: The Ideology of the Gallery Space*. San Francisco: The Lapsus Press, 1986.

Oehlen, Albert. "Zäsur in der Biographie eines Kritiksüchtigen." In *Szene Hamburg* (February 1986): n.p., as cited in Michael Krebber. *Apothekerman*, 4. Exhibition catalogue: Kunstverein Braunschweig / Städtische Galerie Wolfsburg. Cologne: Walther König, 2000.

Ohrt, Roberto. "Die Bedeutung verändern, den Erfolg verändern." In Michèle Bernstein. *Alle Pferde des Königs*, 115–126. Translated by Dino Beck and Anatol Vitouch. Hamburg: Edition Nautilus, 2015.

Ottavi, Marie. *Jacques de Bascher: dandy de l'ombre.* Paris: Editions Séguier, 2017.

Owens, Craig. *From Work to Frame, or, Is There Life After "The Death of the Author"?*, edited by Hannes Loichinger and Megan Francis Sullivan. Berlin: S*I*G, 2021.

Palmen, Conny. *Die Sünde der Frau.* Translated by Hanni Ehlers. Zürich: Diogenes, 2018.

Passot, Odile. "Portrait of Guy Debord as a Young Libertine." Translated by Paul Lafarge. *Substance*, vol. 228, no. 3, issue 90 (1999): 71–88.

Pollock, Griselda. "Modernity and the Spaces of Femininity." In Griselda Pollock. *Vision and Difference: Femininity, Feminism and the Histories of Art*, 70–127. London and New York: Routledge, 2008.

Price, Seth. *Fuck Seth Price: A Memoir.* New York: Leopard, 2015.

Price, Seth. "Wrong Seeing, Odd Thinking, Strange Action." *Texte zur Kunst*, no. 106 (June 2017): 82–84.

Proust, Marcel. *The Lemoine Affaire.* Translated by Charlotte Mandel. New York: Melville House, 2008.

Proust, Marcel. Letter to Raymond Roussel, as cited in Stefan Zweifel. "Chronologie." In Raymond Roussel. *Locus Solus*, 423–80. Berlin: Die Andere Bibliothek, 2012.

Quent, Marcus. *Kon-Formismen. Die Neuordnung der Differenzen.* Berlin: Merve, 2018.

Ra, Sun. As cited in Christopher Stover. "Sun Ra's mystical time." *The Open Space Magazine*, no. 21 (Spring 2018): 106–13.

Rebentisch, Juliane. "Camp Materialism." *Criticism*, vol. 256, no. 2 (Spring 2014): 235–48.

Rigaut, Jacques. *Suizid*. Berlin: Tiamat, 1983.

Roussel, Raymond. *Impressions of Africa. A Novel.* Berkeley/Los Angeles: University of California Press, 1967.

Roussel, Raymond. *How I Wrote Certain of My Books.* Translated by Trevor Winkfield. New York: Sun, 1975.

Sagan, Françoise. *Bonjour Tristesse*. Translated by Irene Ash. New York: Dutton 1955.

Savage, Jon. *England's Dreaming: Anarchy, Sex Pistols, Punk Rock, and Beyond*. New York: St. Martin's Press, 1992.

Schaukal, Richard. *Leben und Meinungen des Herrn Andreas von Balthesser, eines Dandy und Dilettanten.* München: Georg Müller, 1907.

Schenkar, Joan. *The Talented Miss Highsmith: The Secret Life and Serious art of Patricia Highsmith.* New York: St. Martin's Press, 2009.

Schickedanz, Hans-Joachim (ed.). *Der Dandy: Texte und Bilder aus dem 19. Jahrhundert*. Dortmund: Harenberg, 1980.

Schillinger, Jakob. "Oswald Wiener on Dandyism." *October*, no. 170 (Autumn 2019): 31–50.

Schillinger, Jakob. "Service Economy." In *Martin Kippenberger: Bitteschön Dankeschön*, edited by Susanne Kleine, 154–84. Exhibition catalogue, Bonn: Kunst- und Ausstellungshalle der Bundesrepublik Deutschland. Cologne: Snoeck, 2019.

Schmidt-Wulffen, Stephan. *Spielregeln. Tendenzen der Gegenwartskunst*. Köln: DuMont, 1987.

Serner, Walter. *Last Loosening: A Handbook for the Con Artist & Those Aspiring to Become One*. Translated by Mark Kanak. Prague: Twisted Spoon Press, 2020.

Sichtermann, Barbara and Ingo Rose. *Kurtisanen, Konkubinen & Mätressen*. Berlin: Ebersbach & Simon, 2016.

Simpson, Bennett. "Make Your Own Life." In *Make Your Own Life: Artists In & Out of Cologne*, edited by Bennett Simpson, 8–27. Exhibition catalogue. Philadelphia: Institute of Contemporary Art, 2006.

Sontag, Susan. *Notes on "Camp"*. London: Penguin, 2018.

Sanouillet, Michel and Elmer Peterson (eds.). *The Essential Writings of Marcel Duchamp*. London: Thames and Hudson, 1975.

Szeemann, Harald and Jean Clair (eds.). *Le Macchine Celibi / The Bachelor Machines*. Exhibition catalogue. New York: Rizzoli, 1975.

Tacke, Alexandra and Börn Weyand (eds.). *Depressive Dandys: Spielformen der Dekadenz in der Pop-Moderne*. Cologne: Böhlau, 2009.

Theweleit, Klaus. *Buch der Könige: Recording Angels' Mysteries*, vol. 2y. Basel/Frankfurt am Main: Stroemfeld/Roter Stern 1994.

Trilling, Lionel. *Sincerity and Authenticity*. Cambridge, MA/London: Harvard University Press, 1983.

Valéry, Paul. *Monsieur Teste*. Translated by Jackson Mathews. London: Peter Owen, 1951.

Valéry, Paul. *Les Principes d'an-archie pure et appliquée*. Paris: Gallimard, 1984.

Vaneigem, Raoul. *The Revolution of Everyday Life*. Translated by Donald Nicholson-Smith. London: Rebel Press, 2001.

Vugt, Geertjan de. *Political Dandyism in Literature and Art: Genealogy of a Paradigm*. London: Palgrave MacMillan, 2018.

Warhol, Andy. *The philosophy of Andy Warhol (From A to B & Back Again)*. London: Cassell, 1975.

Wehr, Norbert (ed.). *Spiel auf Leben und Tod. Die Auferstehung des Konrad Bayer*, compiled by Erik de Smedt. *Schreibheft: Zeitschrift für Literatur*, no. 79 (September 2012).

Whistler, James Abbott McNeill. *The Gentle Art of Making Enemies*. London: W. Heinemann, 1994.

Wiener, Oswald. *Die Verbesserung von Mitteleuropa, Roman*. Reinbek bei Hamburg: Rowohlt, 1969.

Wiener, Oswald. "Science and Barbarism Go Very Well Together: Interview by Hans-Christian Dany." Translated by Nathaniel McBride. *Spike*, no. 42 (Winter 2014): 115–25.

Wiener, Oswald. "An Ego of Her Own." Translated by Gerrit Jackson with Jakob Schillinger. *October*, no. 170 (Fall 2019): 69–94.

Wilde, Oscar. *The Soul of Man Under Socialism*. London: Journeyman, 1988.

Wilde, Oscar. *The Picture of Dorian Gray*. London: Penguin Books, 2003.

Wilde, Oscar. *De Profundis and Other Prison Writings*. London/New York: Penguin Books, 2013.

Wilde, Oscar. *The Critic as Artist*. New York: David Zwirner Books, 2019.

Williams, Rachel DeLoache. *My Friend Anna: The True Story of a Fake Heiress*. New York: Gallery Books, 2022.

Wilson, Andrew. *Beautiful Shadow: A Life of Patricia Highsmith*. New York: Bloomsbury, 2003.

Woolf, Virginia. *Beau Brummell*. New York: Rimington & Hooper, 1930.

Ziegenfuss, Werner. *Die Überwindung des Geschmacks*. Potsdam: E. Stichnote, 1949.

Zweifel, Stefan. "Chronologie." In Raymond Roussel. *Locus Solus*, 423–80. Berlin: Die Andere Bibliothek, 2012.

Zweifel, Stefan. "Reise ins Herz der Phantasie." In Raymond Roussel. *Eindrücke aus Afrika*, 333–48. Luzern/Poschiavo: Edizioni Periferia, 2016.

Music

Bartos, Karl, Ralf Hütter, and Florian Schneider-
Esleben. "Die Roboter." Released on the single *Die
Roboter* by Kraftwerk. Düsseldorf: Kling Klang, 1978.

Lear, Amanda and Anthony Monn. "Follow Me."
Released on the single *Follow Me* by Amanda Lear.
Munich: Ariola, 1978.

Schamoni, Rocko. "Der Mond." Released on the album
Showtime by Rocko Schamoni. Munich: Trikont, 1999.

Image Credits

Front cover
Montage using Jane Walker, a special edition of
the "Striding Man" developed in 2018 by the drinks
manufacturer Diageo for the US market.

Frontispiece
James Abbott McNeill Whistler, original drawing for
The Gentle Art of Making Enemies, 1890, collage and
pencil on paper, 11.4 × 11.4 cm
Courtesy Galerie Buchholz, Berlin/Cologne/New York

p. 5
John Barrymore as Beau Brummell in Harry Beaumont,
Beau Brummell, Warner Bros. Pictures, USA 1924.

p. 13
William Austin, *The Duchess of Queensberry Playing
at Foils with her Favourite Lap Dog Mungo*, published
on May 1, 1773, etching on laid paper, hand-colored,
27.3 × 37.6 cm

p. 19
Birgit Jürgenssen, *Fehlende Glieder (Missing Limbs)*,
1974, pen, pencil on laid paper, 62.5 × 43.5 cm
© Estate Birgit Jürgenssen / VERBUND
COLLECTION, Vienna

p. 22
Boris Karloff, who played Frankenstein's monster from
Mary Shelley's novel *Frankenstein* (1818), helps Bela
Lugosi with his makeup. Lugosi had been offered
the role first, but turned it down because he had already
made his name as Dracula.

p. 29
Helmut Berger in Massimo Dallamano, *Dorian Gray* /
Il dio chiamato Dorian, Sargon Film / Terra-Filmkunst /
Towers of London, Germany/Italy 1970.

p. 43
Michael Krebber, *M. Teste* from the installation
Flaggs (Against Nature), 2003, fabric, stretcher frames,
16 parts, each 153.6 × 124.4 cm
© Michael Krebber / Collection Bonnefantenmuseum,
Maastricht

p. 44
Buster Keaton (1928) in one of the many promotional
pictures showing him with or as a puppet in the 1920s.

p. 49
The illustration is a digital reproduction of a drawing
by Henri-Achille Zo for Raymond Roussel's *Nouvelles
Impressions d'Afrique* (Paris: Librairie Alphonse
Lemerre, 1932).
Courtesy Collection Daniel Buchholz & Christopher
Müller, Cologne

p. 54
Reproduction of a postcard of the Grand Hôtel et
Des Palmes, Palermo, n.d.

p. 60
Guy Debord's *Game of War* (position 47), illustration
taken from Alice Becker-Ho and Guy Debord,
Le "Jeu de la guerre" (Paris: Éditions Gérard Lebovici,
1987), 110.

p. 71
Advertisement for van Laack shirts, with Marcel
Broodthaers as model, published in *Der Spiegel*, vol. 25,
no. 13 (March 22, 1971): 166.

p. 74
Advertisement for Nikka Whiskey with Joseph Beuys
from 1985, illustration taken from Johannes Stüttgen,
*Zeitstau. Im Kraftfeld des erweiterten Kunstbegriffs
von Joseph Beuys* (Stuttgart: Urachhaus, 1988), 72.

p. 77
Sturtevant, *Beuys La rivoluzione siamo noi*, 1988,
silkscreen on paper, 95.5 × 51 cm
© Estate Sturtevant, Paris / Courtesy Galerie
Thaddaeus Ropac, London/Paris/Salzburg

p. 86
Gordon Parks, *Invisible Man Retreat, Harlem,
New York*, 1952, gelatin silver print, 76.2 × 61 cm
© and Courtesy The Gordon Parks Foundation,
New York

p. 89
Hanne Darboven in New York
© Roy Colmer, ProLitteris, Zurich, and Hanne
Darboven Foundation, Hamburg / Courtesy Claudia
Colmer

p. 95
Lutz Bacher at the beach
Photo: Robert Snowden
Courtesy Estate of Lutz Bacher and Galerie Buchholz,
Berlin/Cologne/New York

p. 100
Tear-out of an ad published in the 1985 US edition
of *Rolling Stone* magazine in which Andy Warhol
promotes hair care products made by Vidal Sassoon.

p. 107
Jako, perfume launched in 1996 by Karl Lagerfeld
in honor of Jacques de Bascher.
Courtesy Collection Kévin Blindermann,
Pierre-Alexandre Mateos, and Charles Teyssou

p. 111
Yves Saint Laurent and Jacques de Bascher during
a cocktail party organized for Andy Warhol at Yves's
place—55 rue de Babylone—in Paris on February 25, 1974.
Photo: Philippe Heurtault
© and Courtesy Philippe Heurtault

p. 114
Philippe Morillon, *Les sapeurs à la Main Bleue,* 1980
Courtesy Philippe Morillon

p. 119
Ken Russell, *In Your Dreams*, 1955
© Ken Russell / TopFoto

p. 122
Otto Bettmann, *Boys Wearing Looted Formal Wear,*
1943, gelatin silver print
Via Getty Images
Walker Roberts, 12, Henry Campbell, 14, and Morris
Jackson, 13, show off their new "zoot suits"—tuxedos
looted from a formalwear shop during the Harlem riots
of August 1943.

p. 130
Ulrike Ottinger, *Dance. Tabea Blumenschein and Martin Kippenberger*, Berlin, 1978

p. 135
Ursula Böckler, *Documentation for "Gas Station Martin Bormann"*, 1986, prints on baryta paper, 1/12 (Ed. 7)
Courtesy the artist

p. 146
Oswald Wiener, *First and only action with O. Wiener, Ingrid Schuppan, Kurt Kalb, Dominik Steiger, Robert Klemmer and wife, Michel Würthle, Traudl Bayer*, 1967 (2000), b/w photograph, 30.5 × 24.5 cm
Photo: Ludwig Hoffenreich
© mumok - Museum moderner Kunst Stiftung Ludwig Wien / Courtesy Oswald Wiener

p. 151
Jack Smith, *No President*, 1967–70, film still
© Jack Smith Archive / Courtesy Gladstone Gallery

p. 158
Back of a drinks menu of the Hotel Bellevue Palace in Bern from the last century.

p. 161
Gustav Doré, *Le Petit Poucet*, engraving on wood by Adolphe Pannemaker, 19.4 × 24.2 cm, illustration taken from Charles Perrault, *Contes* (Paris: J. Hetzel, 1862), 10.
© Bibliothèque nationale de France

p. 166
Jos de Gruyter & Harald Thys, *Untitled (Skeletons)*, 2009,
b/w print mounted on MDF, 84 × 119 cm
Courtesy the artists and Galerie Micheline Szwajcer

p. 171
Bernadette Van-Huy, *Picnoleptic*, 2018, digital print
(framed), 41.9 × 54.6 cm
Courtesy the artist and Collection Paul Leong,
New York

p. 177
Francis Bruguière, photograph of *R.U.R. (Rossum's
Universal Robots)*, produced by the Theatre Guild,
1922, illustration taken from Karel Čapek, *R.U.R.*
(New York: Doubleday, Page & Company, 1923).
© Wikimedia Commons / Public Domain

p. 182
Miriam Laura Leonardi, *N° 8001*, 2020, HD video
(no sound), 2'30"

p. 191
Heji Shin, *Mamma 1*, 2019, pigment print, 75 × 55 cm
Courtesy Galerie Buchholz, Berlin/Cologne/New York

Cover, reverse
Montage using the Johnnie Walker figure in the
John Geary-designed version of the 1996 *Keep Walking*
campaign.

Imprint

Editors: Valérie Knoll, Hannes Loichinger
Publisher: Sternberg Press
Distribution: The MIT Press, Art Data,
Les presses du réel, and Idea Books
Design: HIT, Berlin
Printing: Druckerei Rüss, Potsdam
Translation: Nathaniel McBride
Copyediting, proofreading: Margaret May

ISBN: 978-3-95679-561-9
Printed in Germany

The book is published as a sequel to the exhibition
"No Dandy, No Fun" (curated by Hans-Christian Dany
and Valérie Knoll), which was shown at the Kunsthalle
Bern from October 17, 2020 to February 14, 2021.

Kunsthalle Bern and the curators would like to thank:
the artists of the exhibition Kai Althoff, Lutz Bacher,
Kévin Blinderman / Pierre-Alexandre Mateos / Charles
Teyssou, Marcel Broodthaers, Ursula Böckler, Marc
Camille Chaimowicz, Stephan Dillemuth, Victoire
Douniama, Lukas Duwenhögger, Cerith Wyn Evans,
Sylvie Fleury, Andrea Fraser, Sophie Gogl, Gogo Graham,
Jos de Gruyter & Harald Thys, David Hammons,
Birgit Jürgenssen, K Foundation, John Kelsey, Michael
Krebber, Miriam Laura Leonardi, David Lieske,
Mathieu Malouf, Ulrike Ottinger, Mathias Poledna,

Heji Shin, Reena Spaulings, and Bernadette Van-Huy; and the lenders arsenal, Berlin, Daniel Buchholz and Christopher Müller, Cologne, Cabinet Gallery, London, Claudia Colmer, Los Angeles, Hanne Darboven Foundation, Hamburg, Estate of Lutz Bacher and Galerie Buchholz, Berlin/Cologne/New York, Estate Birgit Jürgenssen, Vienna, Estate Marcel Broodthaers, Brussels, Estate Sturtevant, Paris and Galerie Thaddaeus Ropac, London/Paris/Salzburg, Galerie Maria Bernheim, Zurich, Galerie Lars Friedrich, Berlin, Galerie Nagel Draxler, Berlin/Cologne/Munich, Galerie Neu, Berlin, Galerie Micheline Szwajcer, Antwerp, Galerie Sprüth Magers, Berlin/London/Los Angeles/New York, Galerie Hubert Winter, Vienna, Paul Leong, New York, Collection Cosima von Bonin, Cologne, Collection Heinz Brand, Bern, Collection Ringier, Zürich, Collection Alexander Schröder, Berlin, VERBUND COLLECTION, Vienna, Robert Snowden, Svetlana, New York.

The exhibition and the publication were kindly supported by Kultur Stadt Bern, Ruth & Arthur Scherbarth Stiftung and the Ernst & Olga Gubler-Hablützel Stiftung.

Kultur
Stadt Bern

KUNSTHALLE BERN

Kunsthalle Bern
Helvetiaplatz 1
CH-3005 Bern
www.kunsthalle-bern.ch

Sternberg Press

Sternberg Press
71–75 Shelton Street
UK-London WC2H 9JQ
www.sternberg-press.com